meow

Peter Slater

Copyright © 2019 by Peter Slater All rights reserved. This book or any portion thereof may not be reproduced or used in any manner whatsoever without the express written permission of the publisher except for the use of brief quotations in a book review. Printed in the United States of America

CATS CAN BE VERY FUNNY, AND HAVE THE ODDEST WAYS
OF SHOWING THEY'RE GLAD TO SEE YOU.

W. H. AUDEN

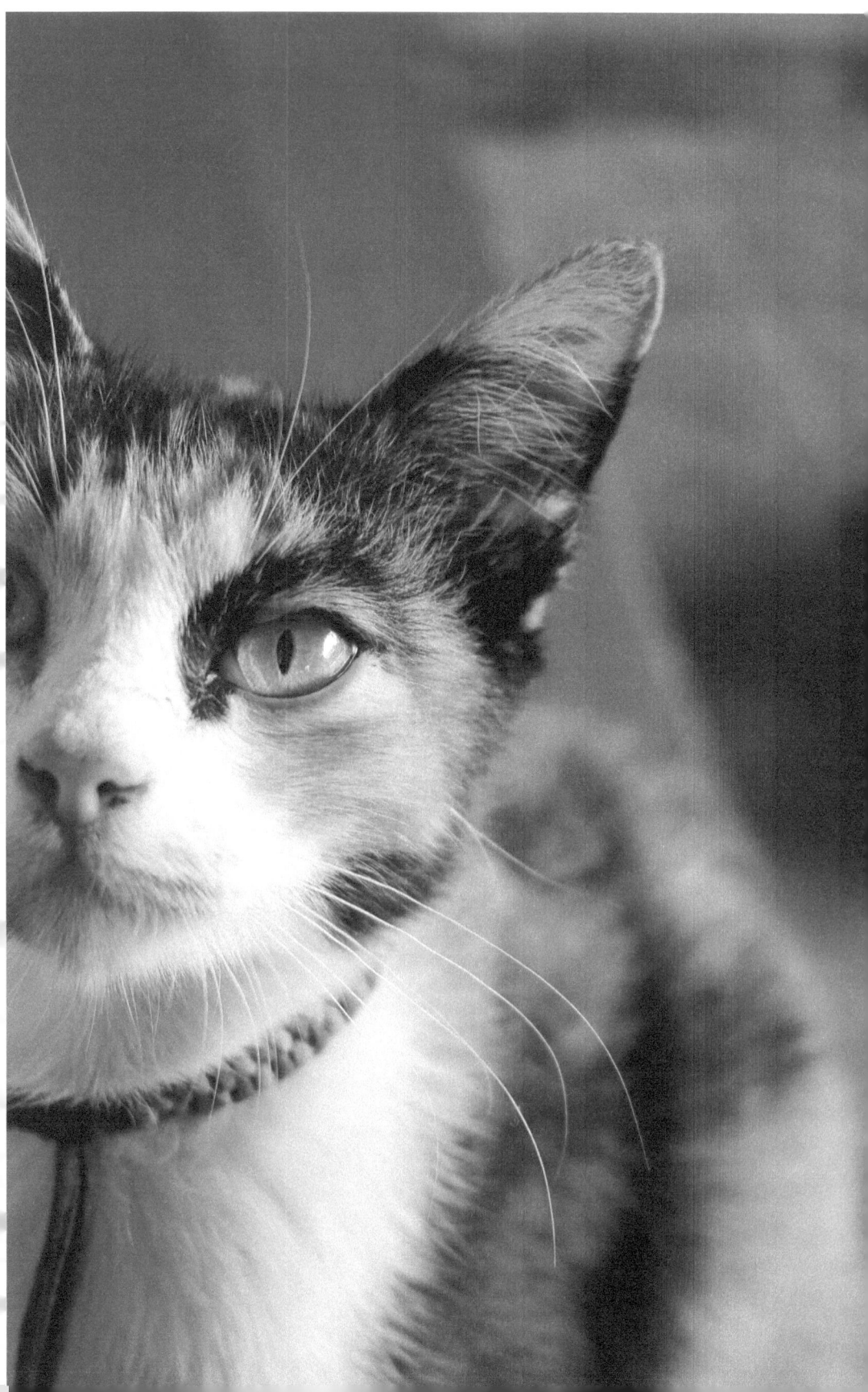

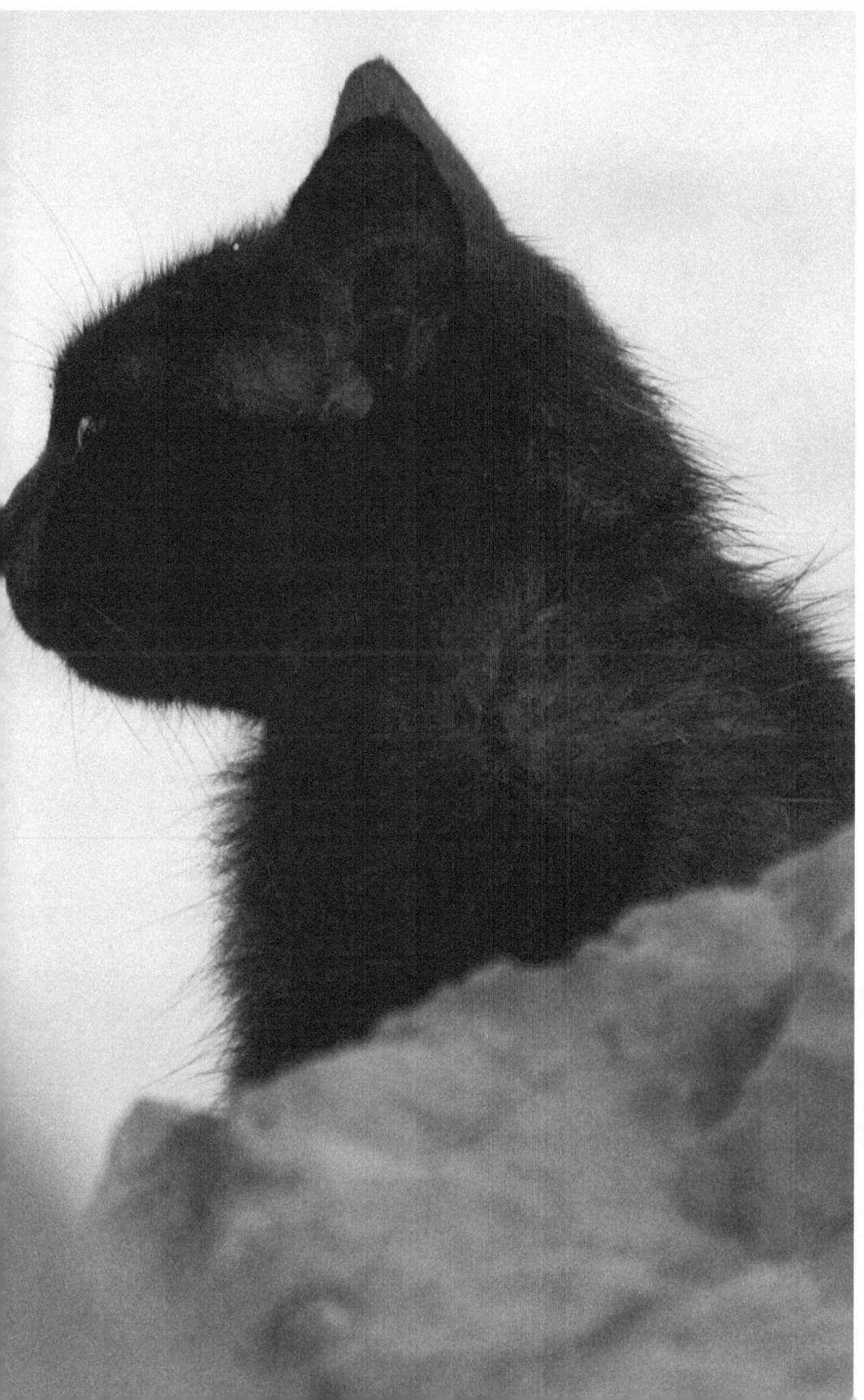

IN A CAT'S EYE, ALL THINGS BELONG TO CATS.

JOSEPH WOOD KRUTCH

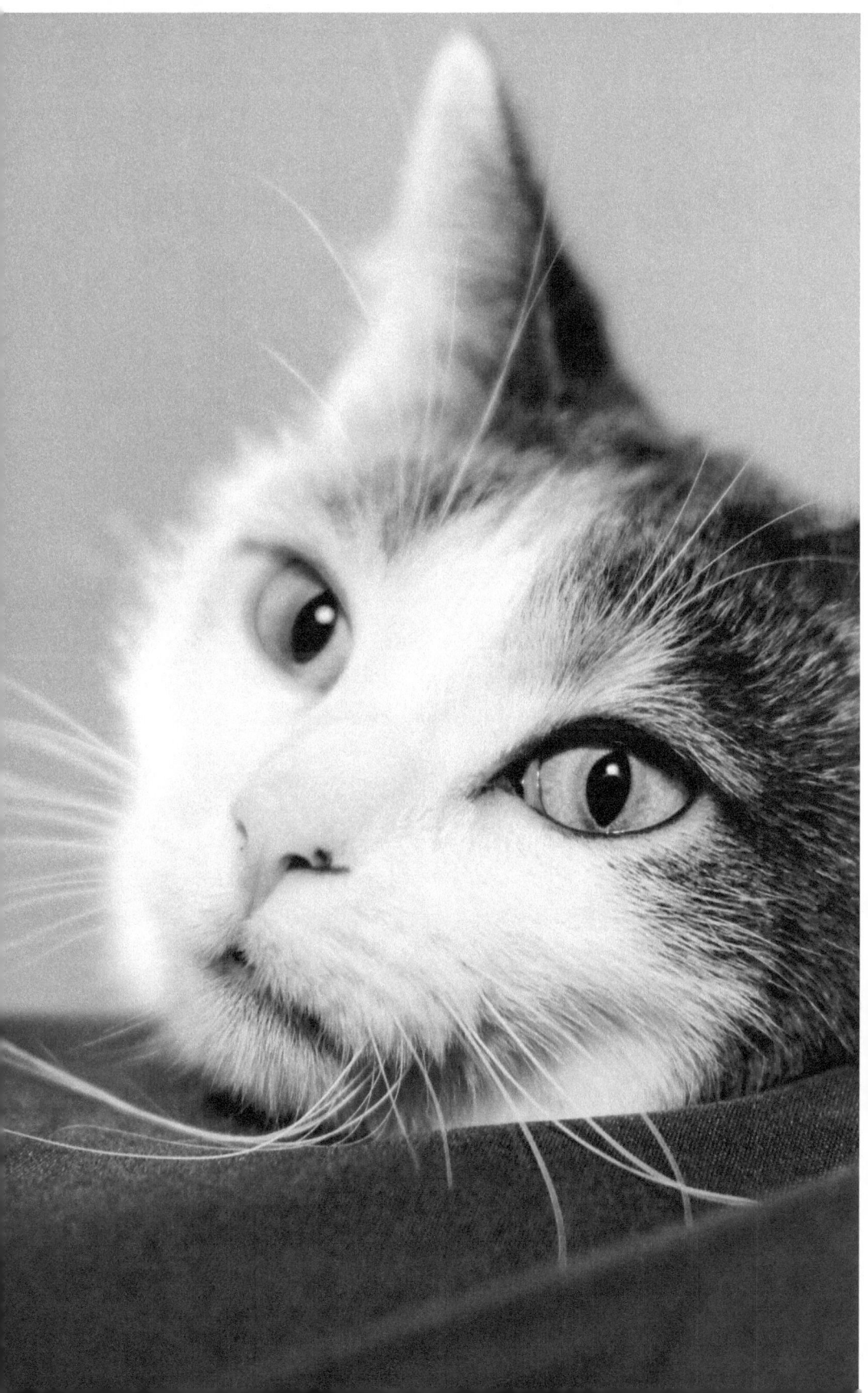

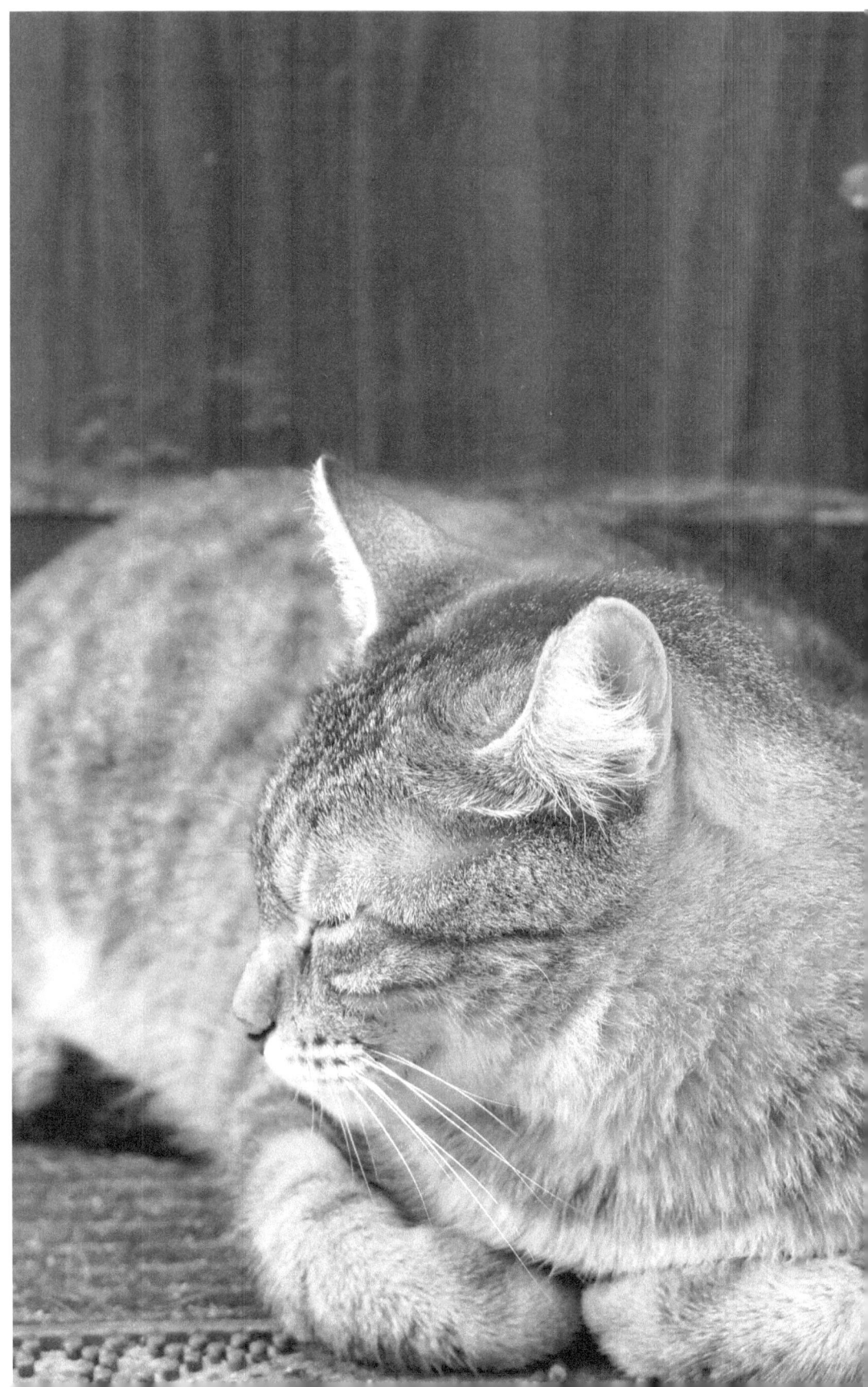

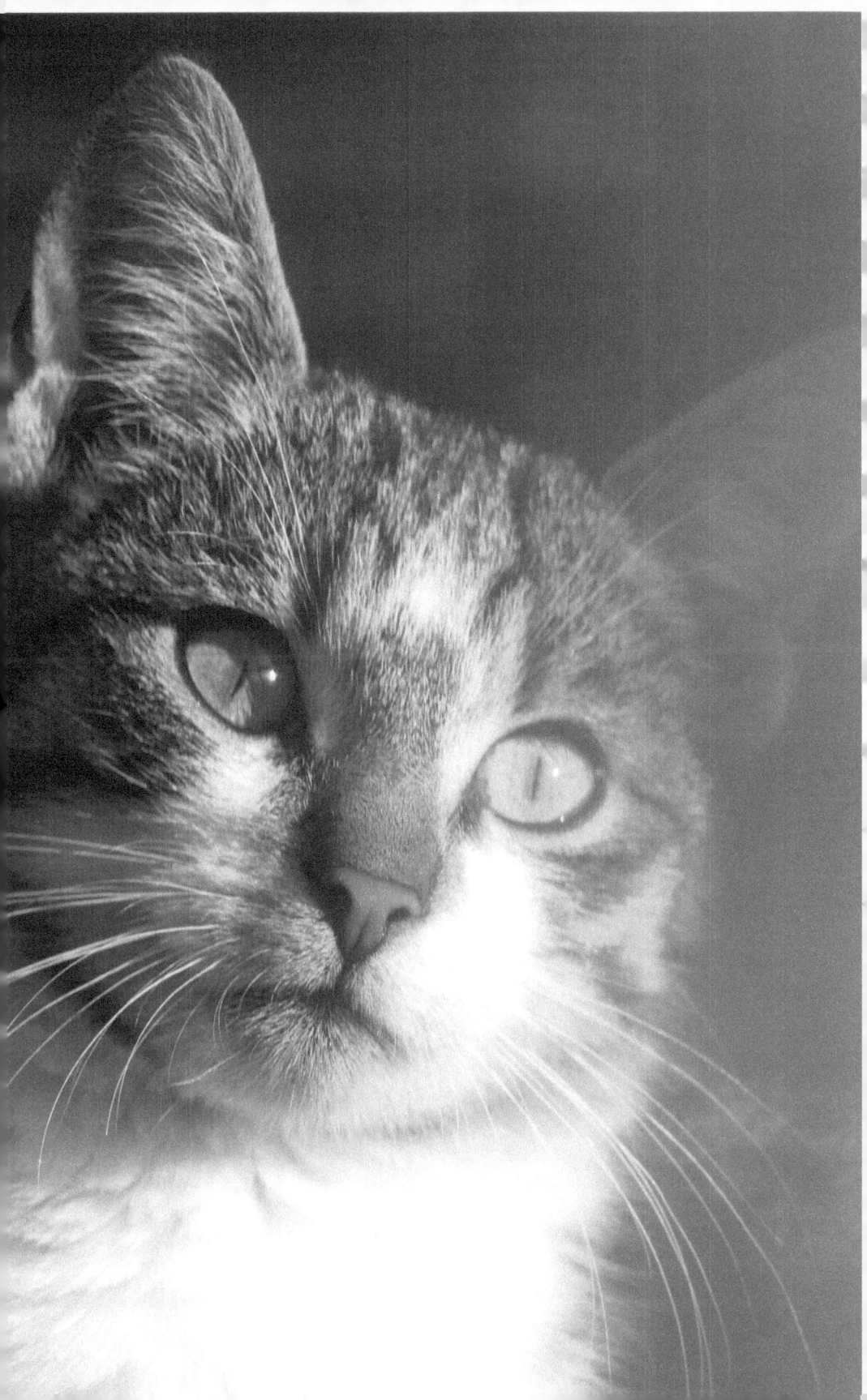

TIME SPENT WITH CATS IS NEVER WASTED.

SIGMUND FREUD

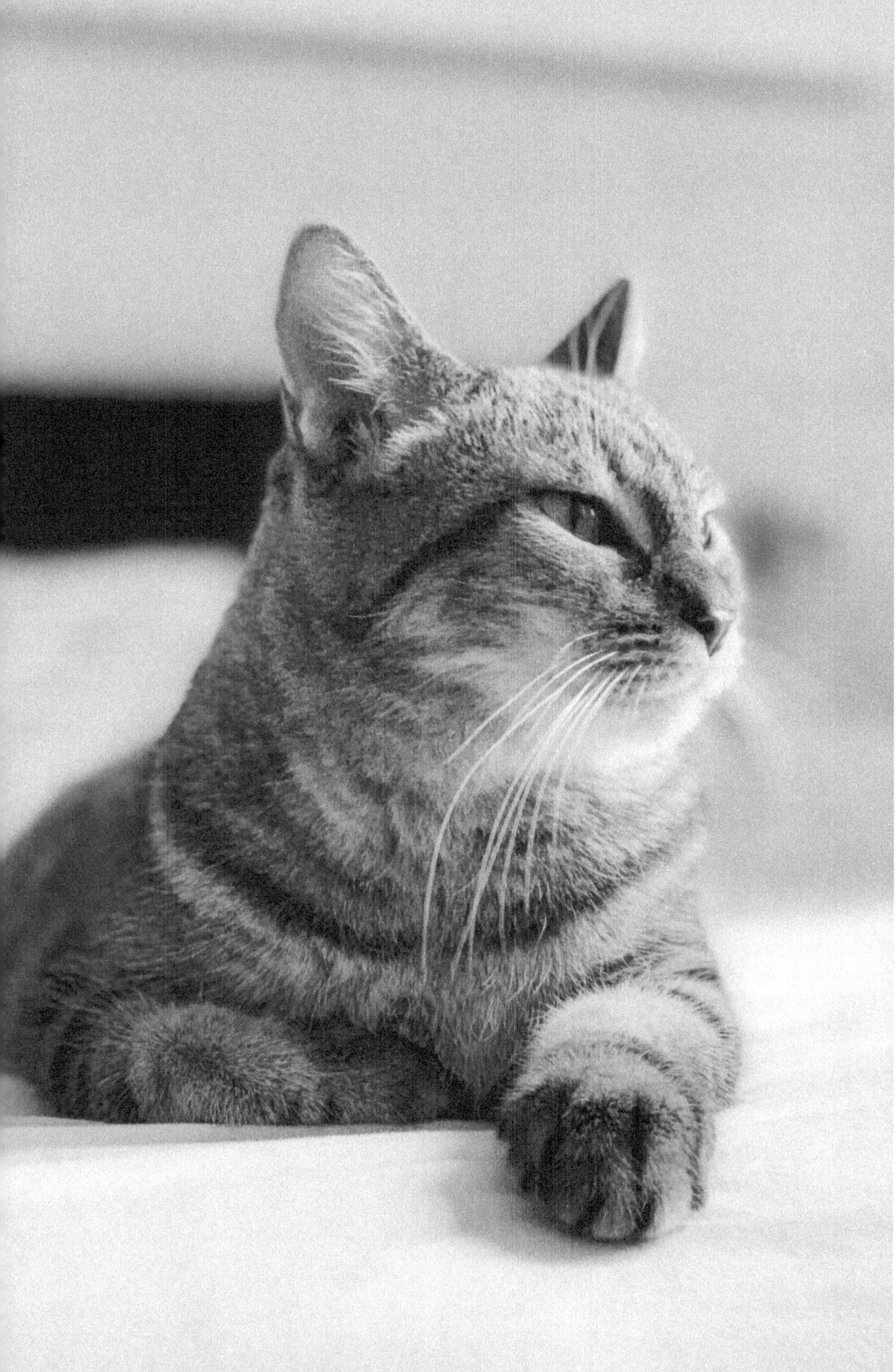

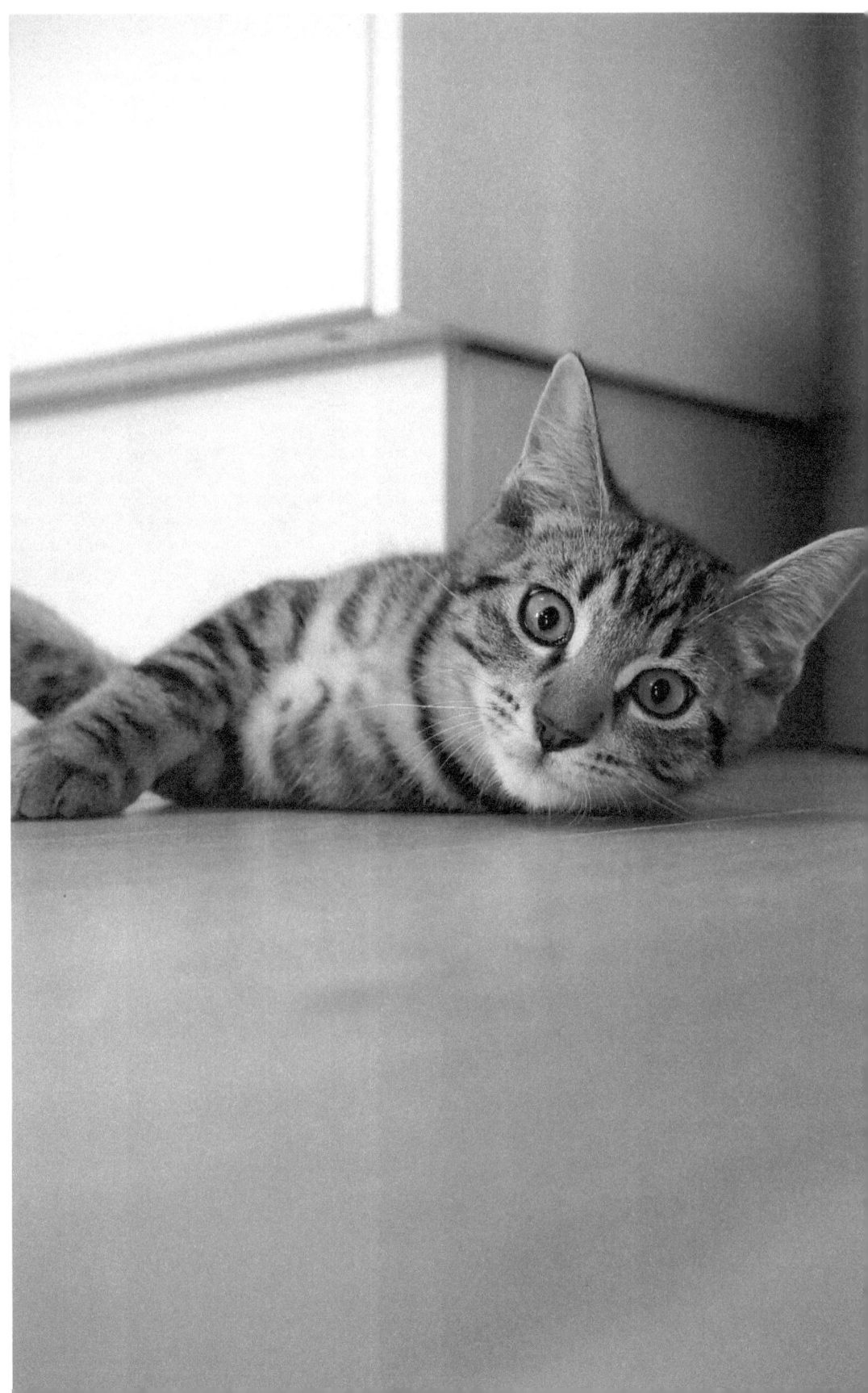

IF ANIMALS COULD SPEAK, THE DOG WOULD BE A BLUNDERING OUTSPOKEN FELLOW; BUT THE CAT WOULD HAVE THE RARE GRACE OF NEVER SAYING A WORD TOO MUCH.

MARK TWAIN

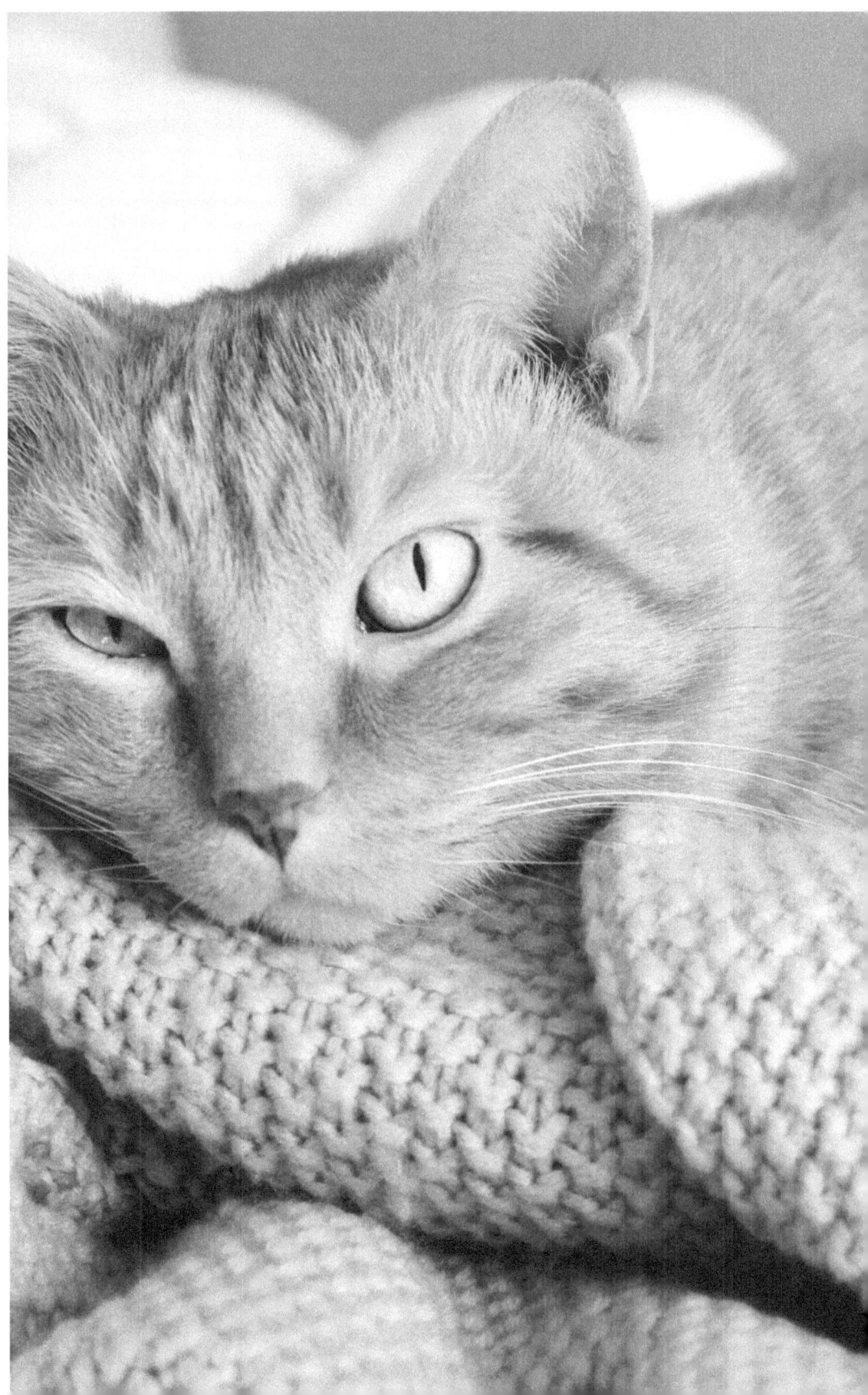

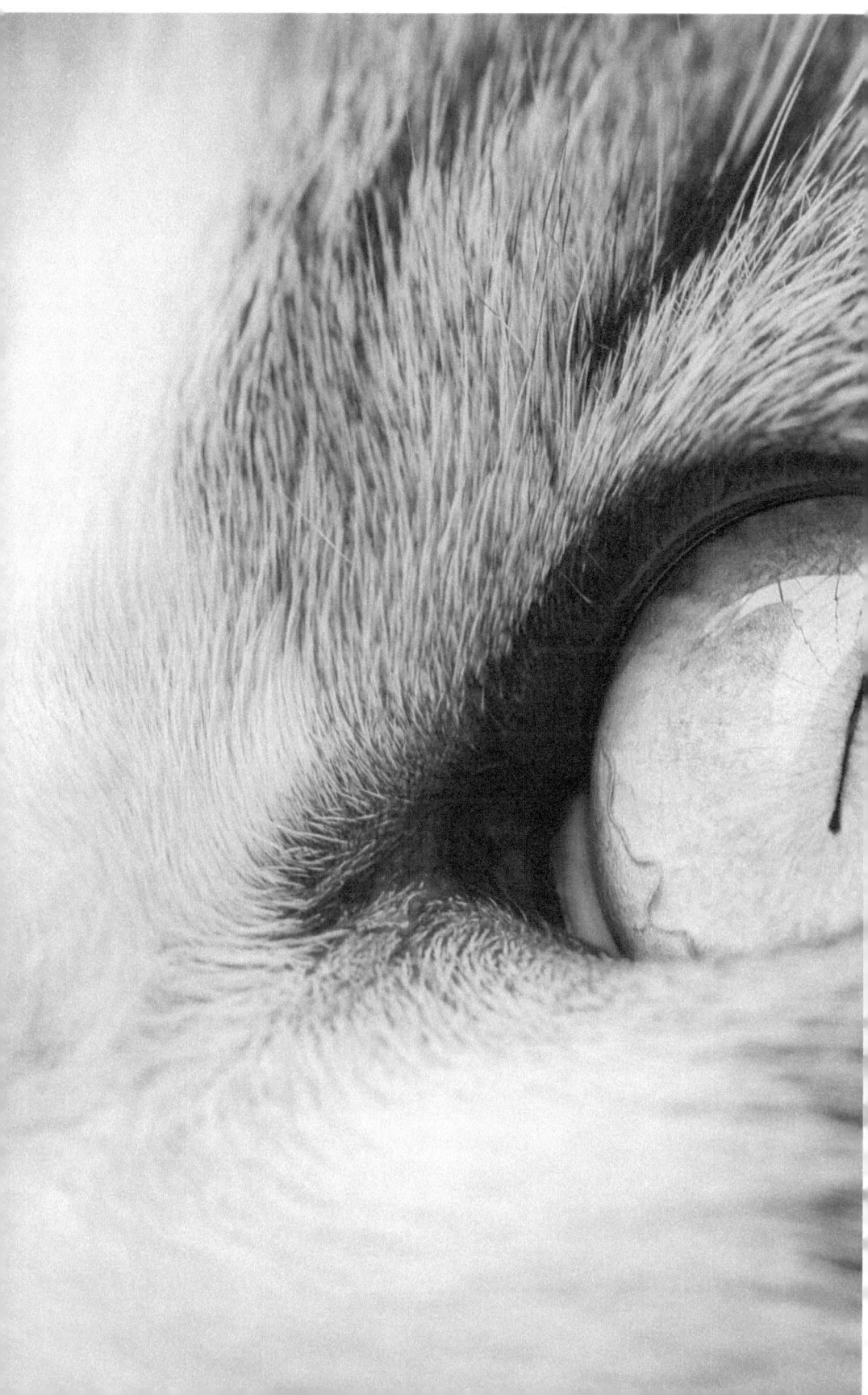

WHEREVER A CAT SITS, THERE SHALL HAPPINESS BE FOUND.

STANLEY SPENCER

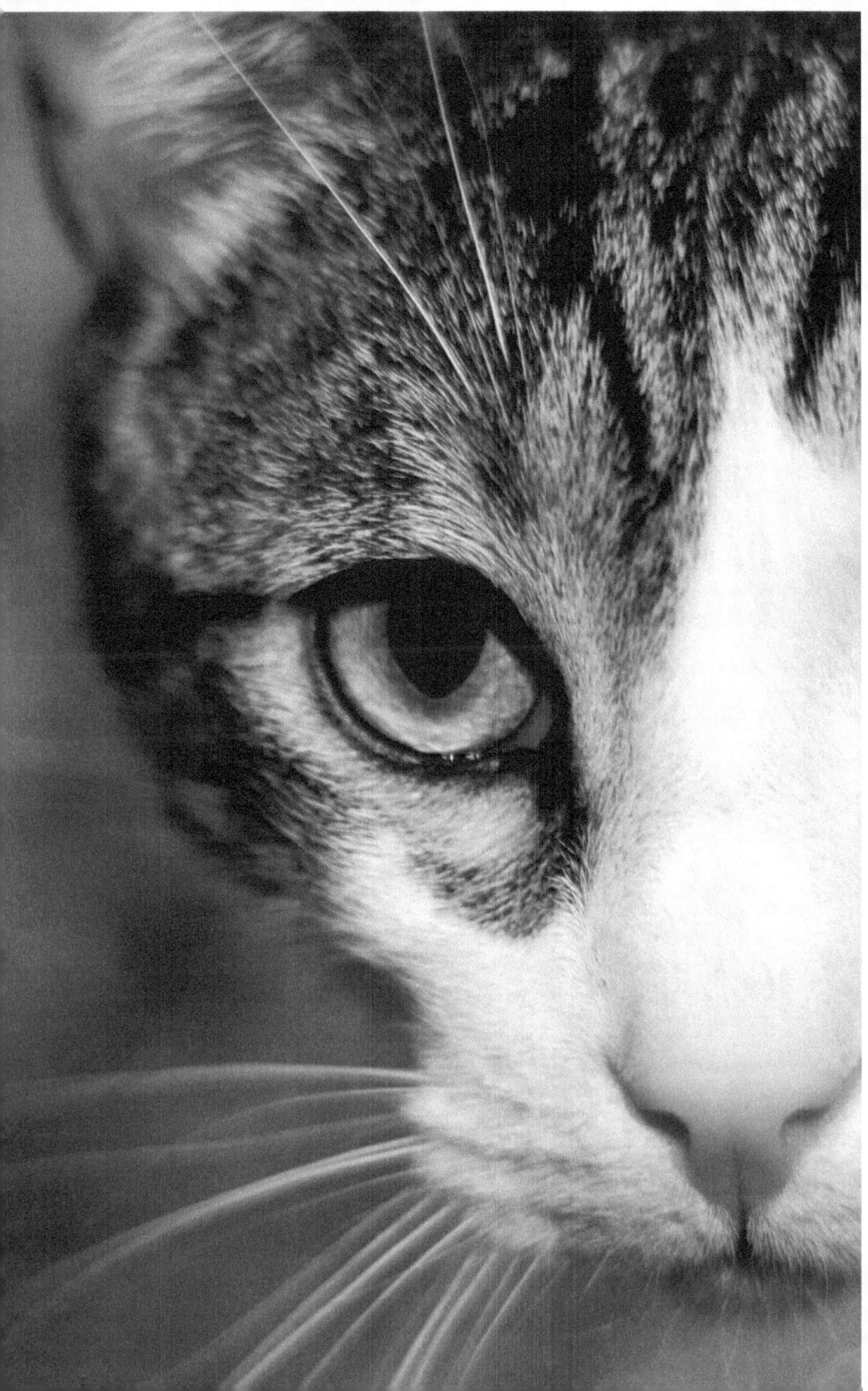

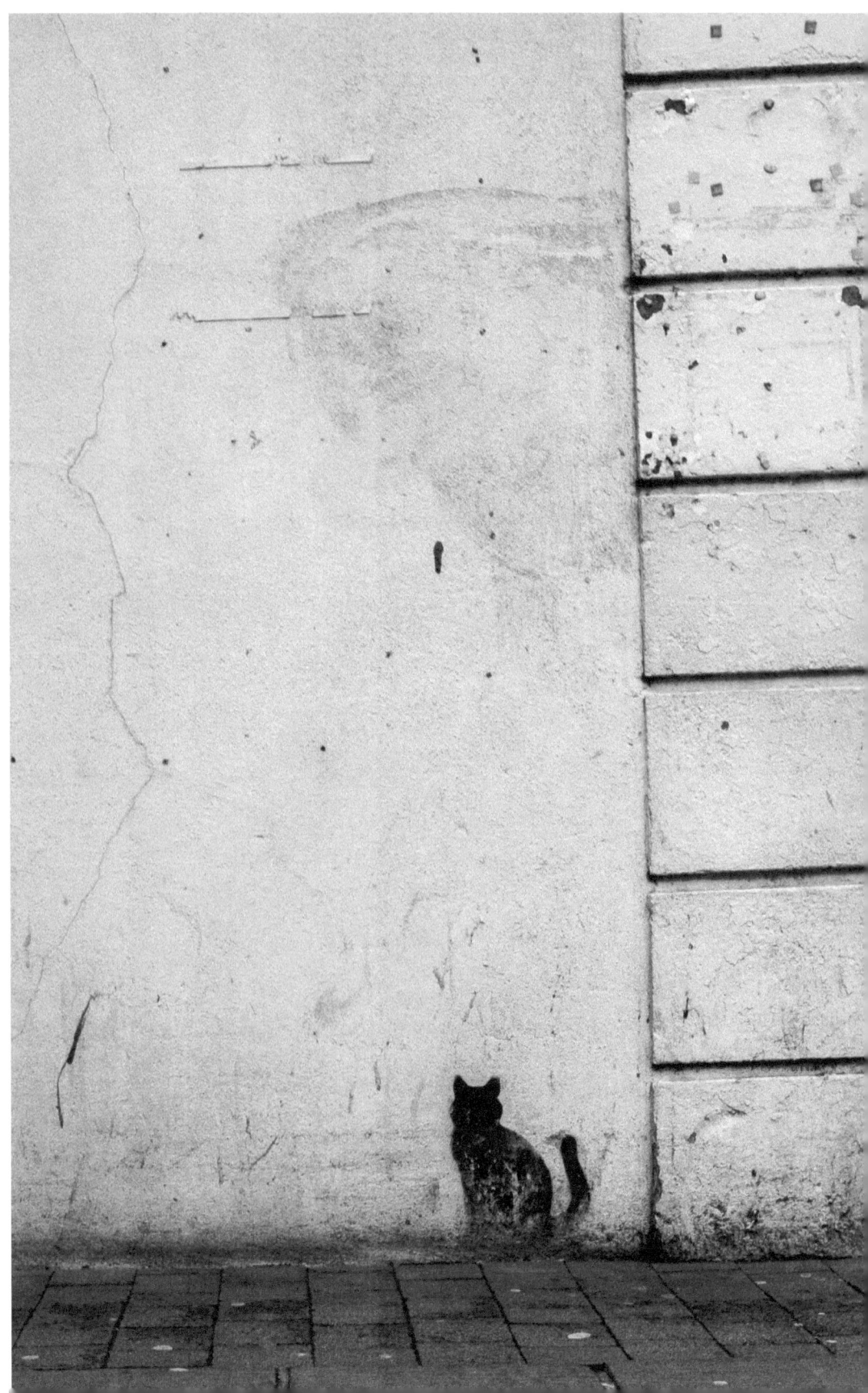

IF YOU ARE WORTHY OF ITS AFFECTION, A CAT WILL BE YOUR FRIEND BUT NEVER YOUR SLAVE.

THEOPHILE GAUTIER

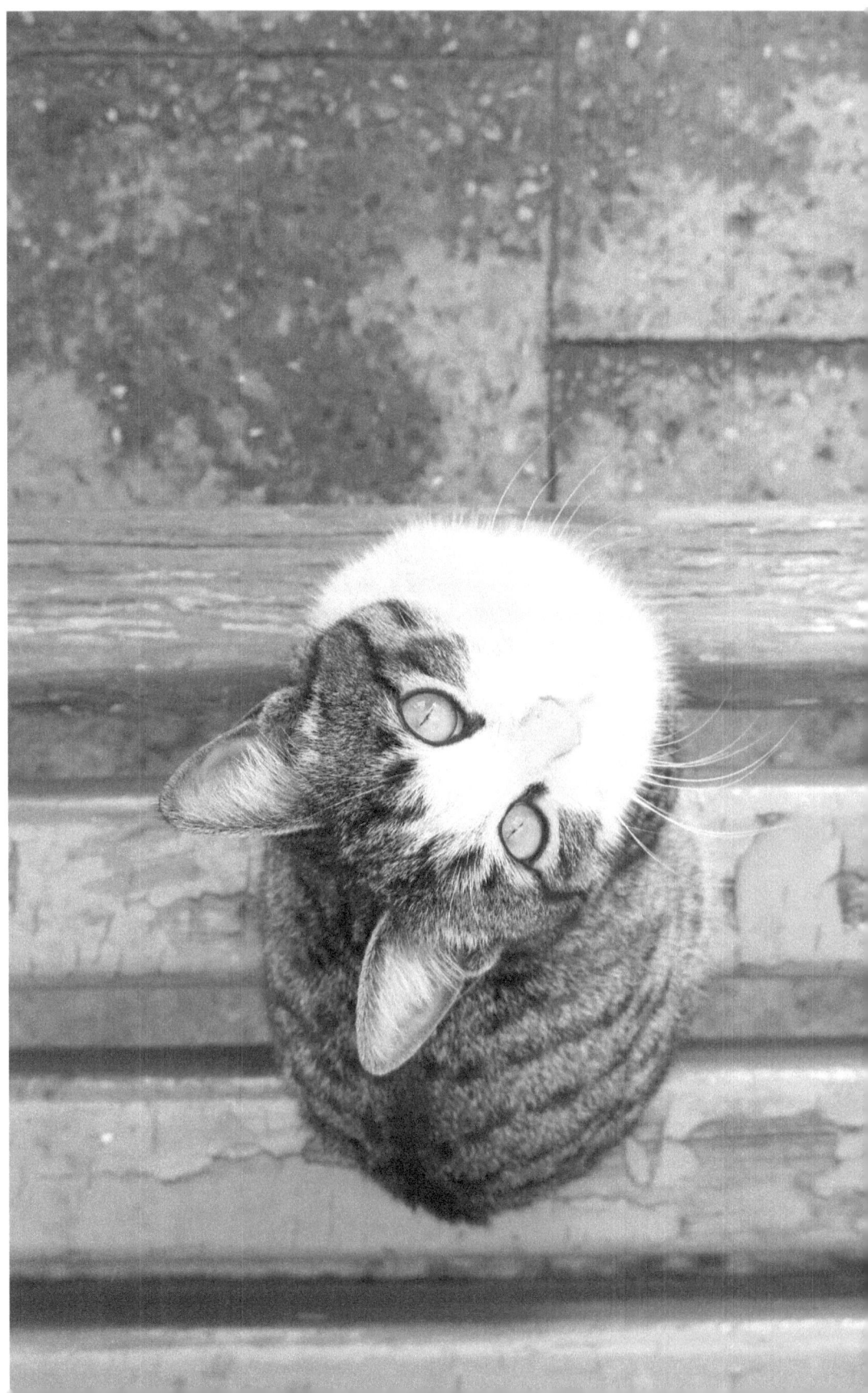

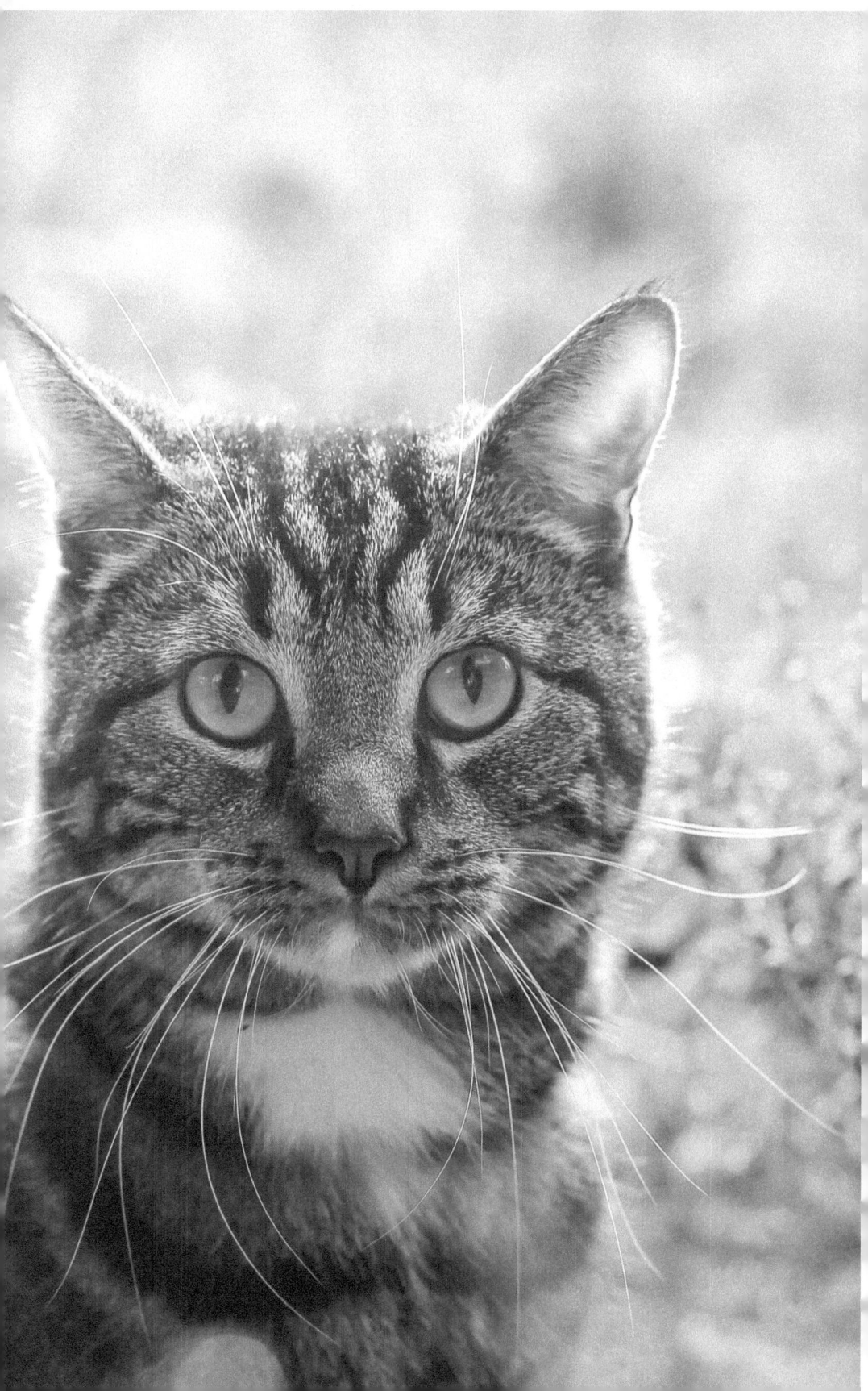

THE CAT IS NATURE'S MASTERPIECE.

LEONARDO DA VINCI

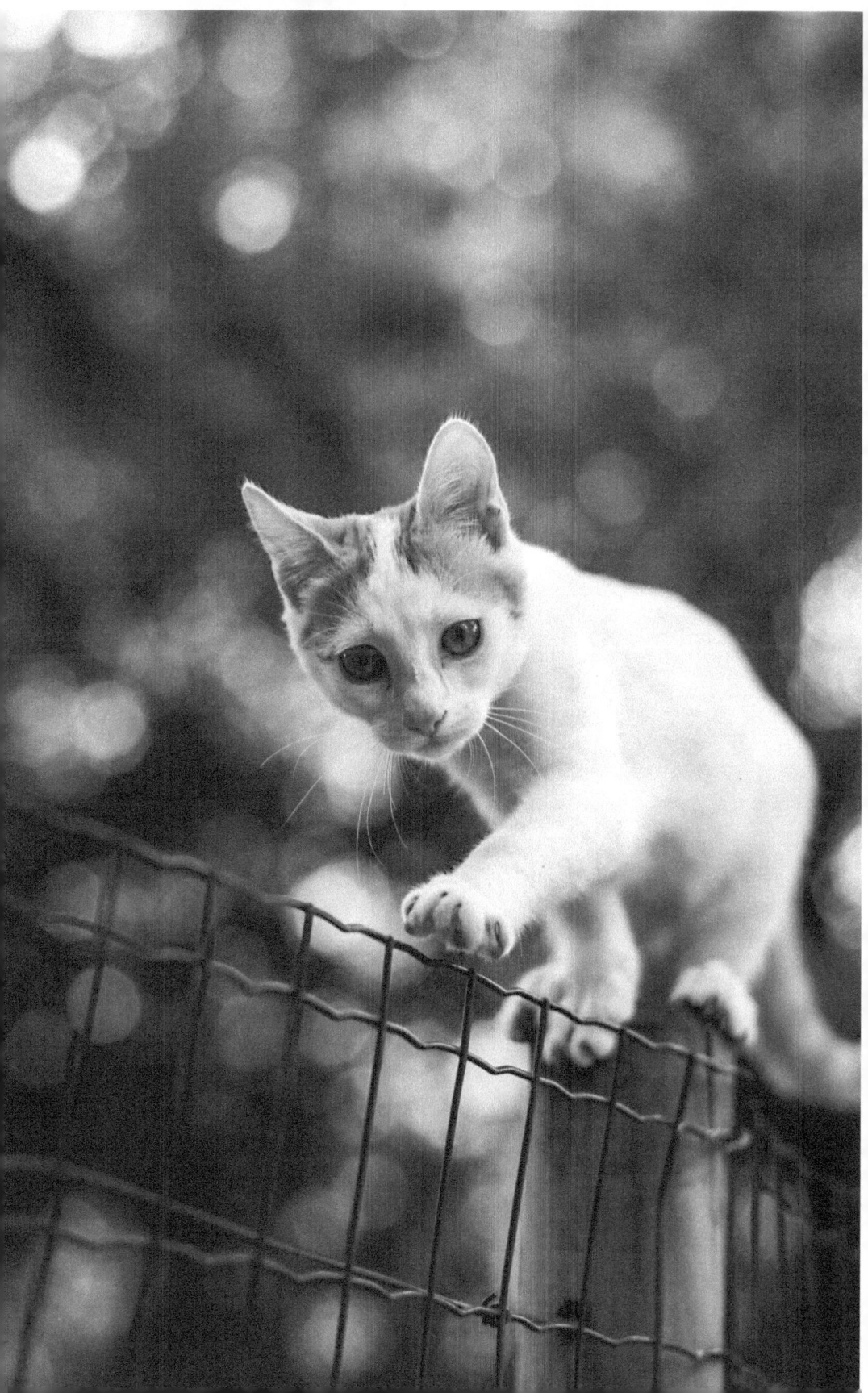

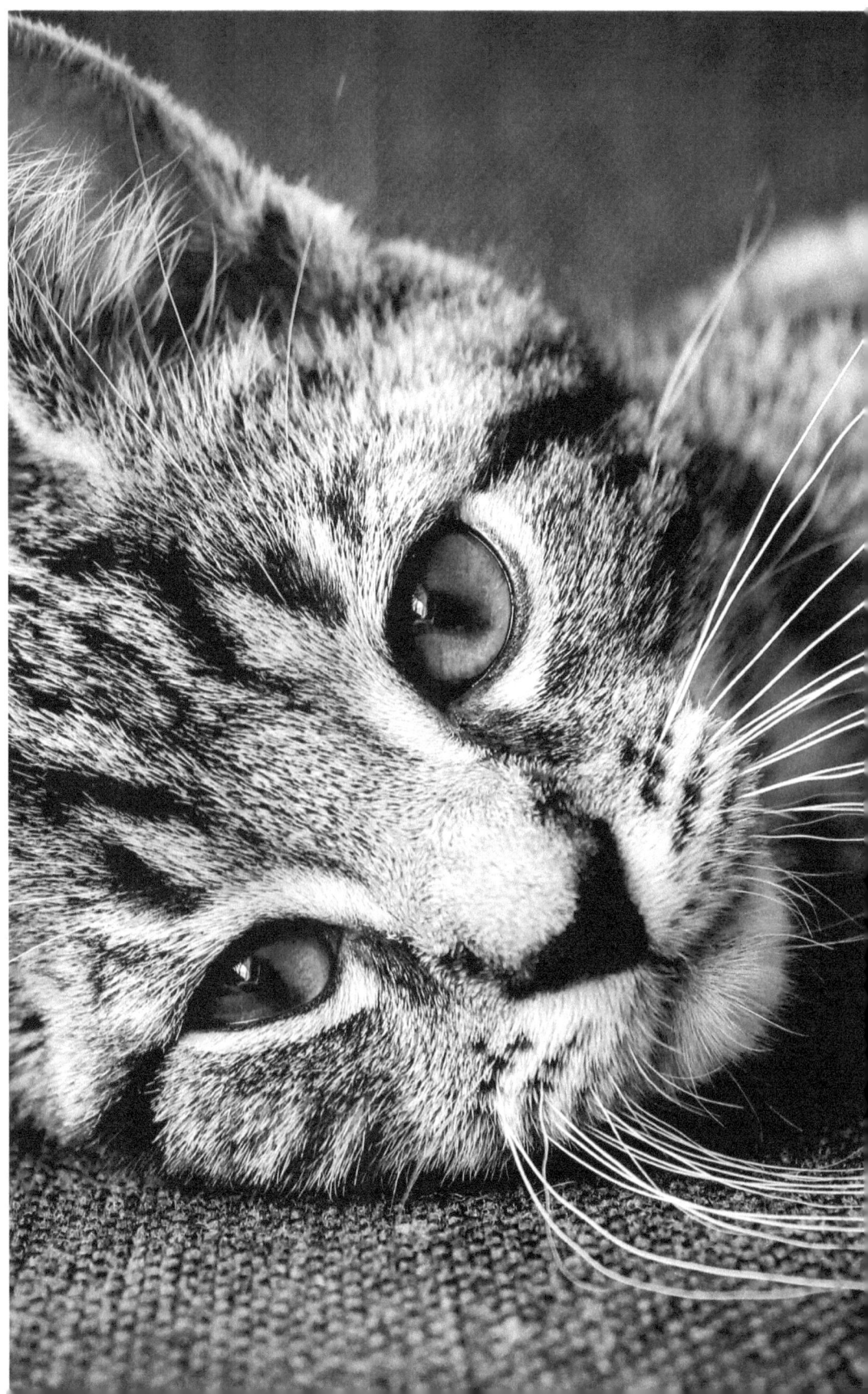

WOMEN AND CATS WILL DO AS THEY PLEASE, AND MEN
AND DOGS SHOULD RELAX AND GET USED TO THE IDEA.

ROBERT A. HEINLEIN

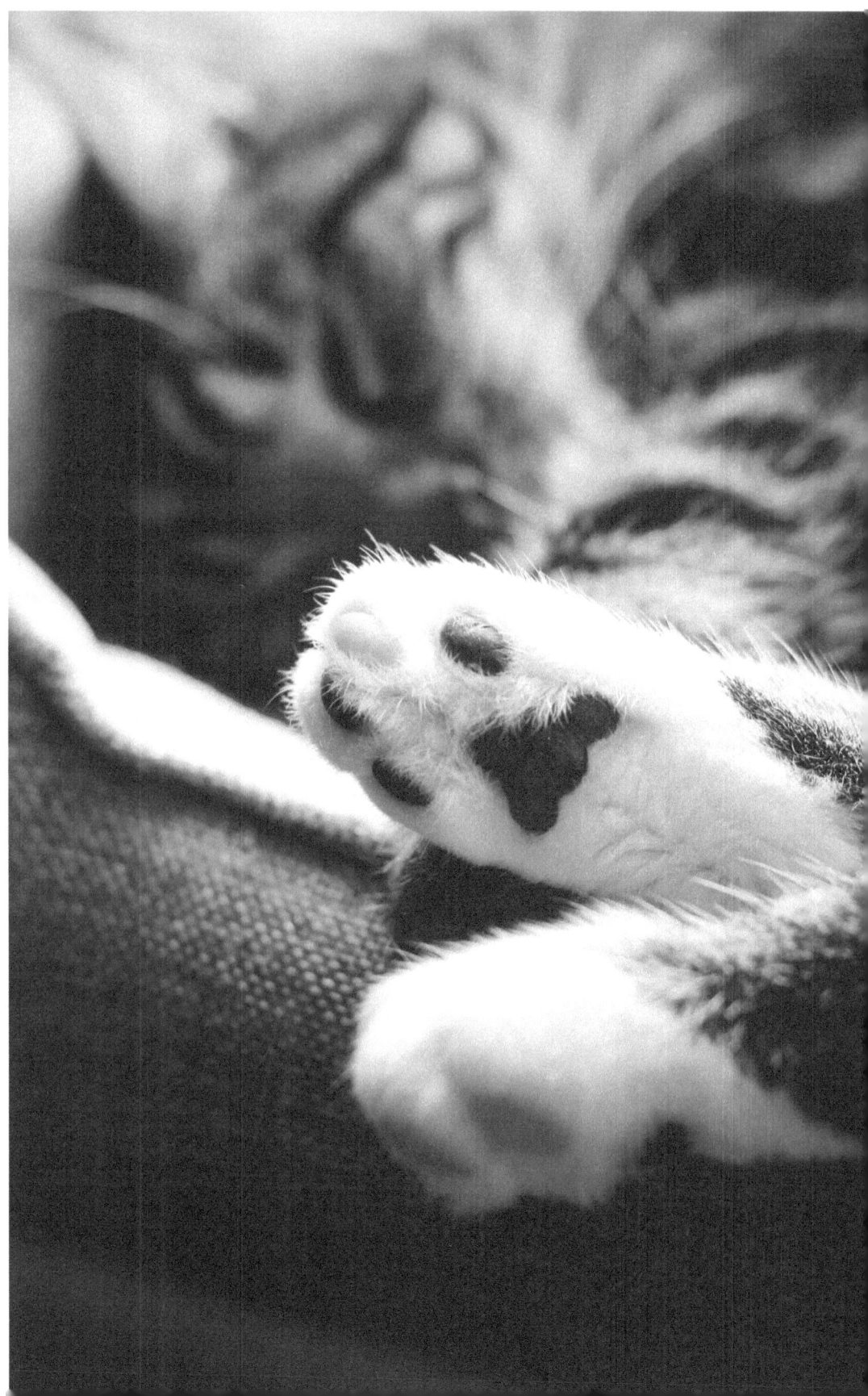

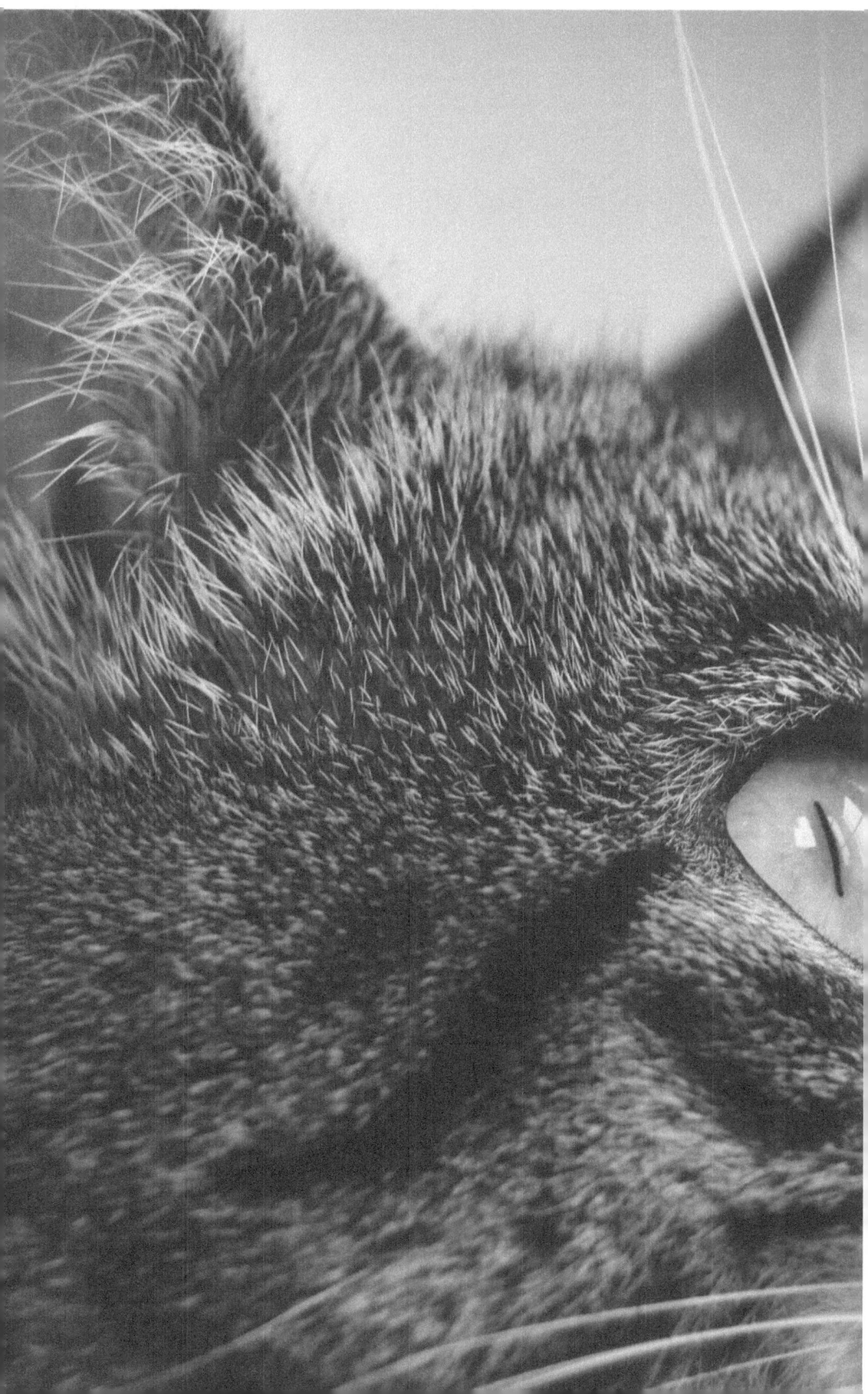

THE CAT DOES NOT OFFER SERVICES. THE CAT OFFERS ITSELF.

WILLIAM S. BURROUGHS

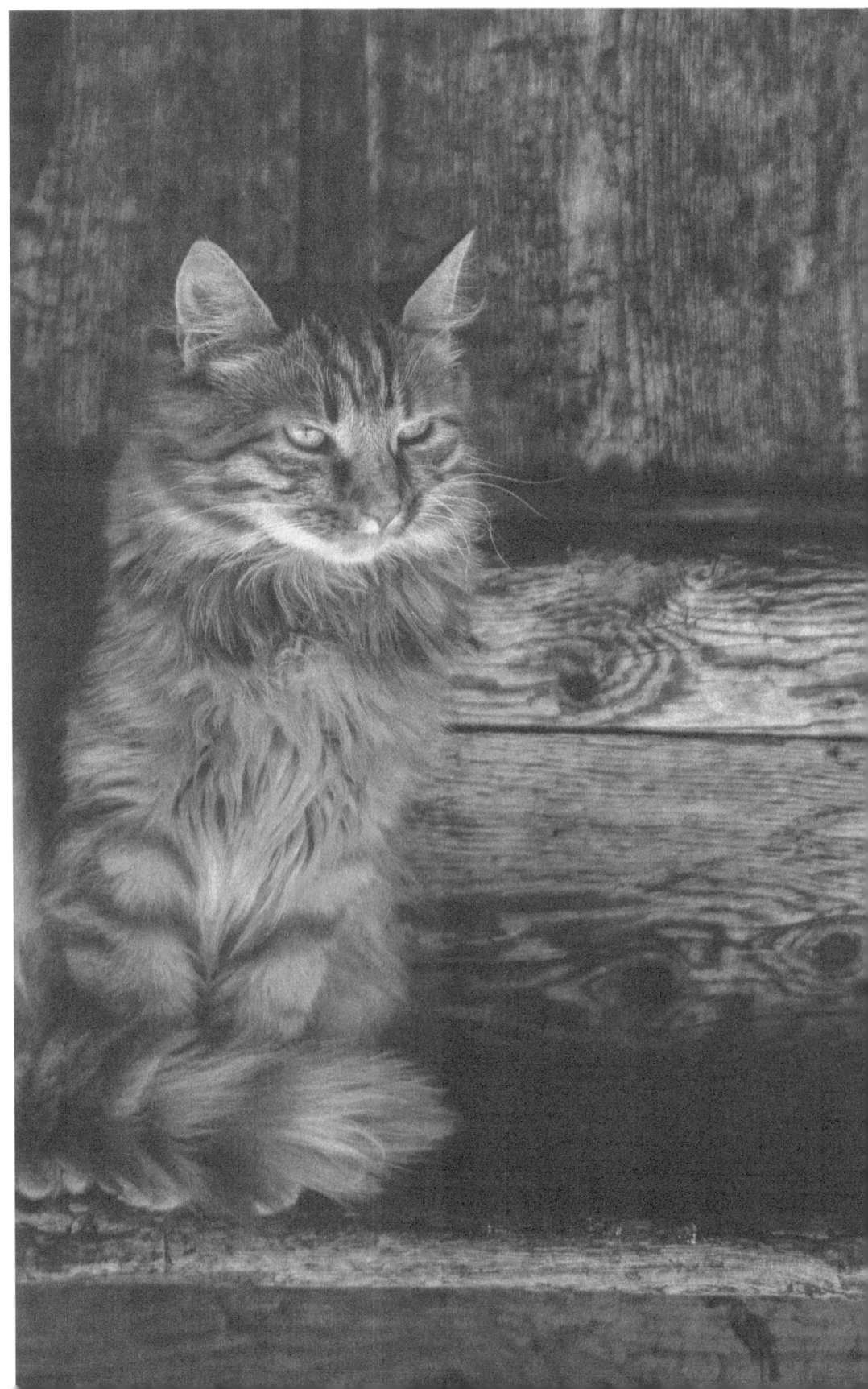

I LOVE CATS BECAUSE I ENJOY MY HOME; AND LITTLE BY LITTLE, THEY BECOME ITS VISIBLE SOUL.

JEAN COCTEAU

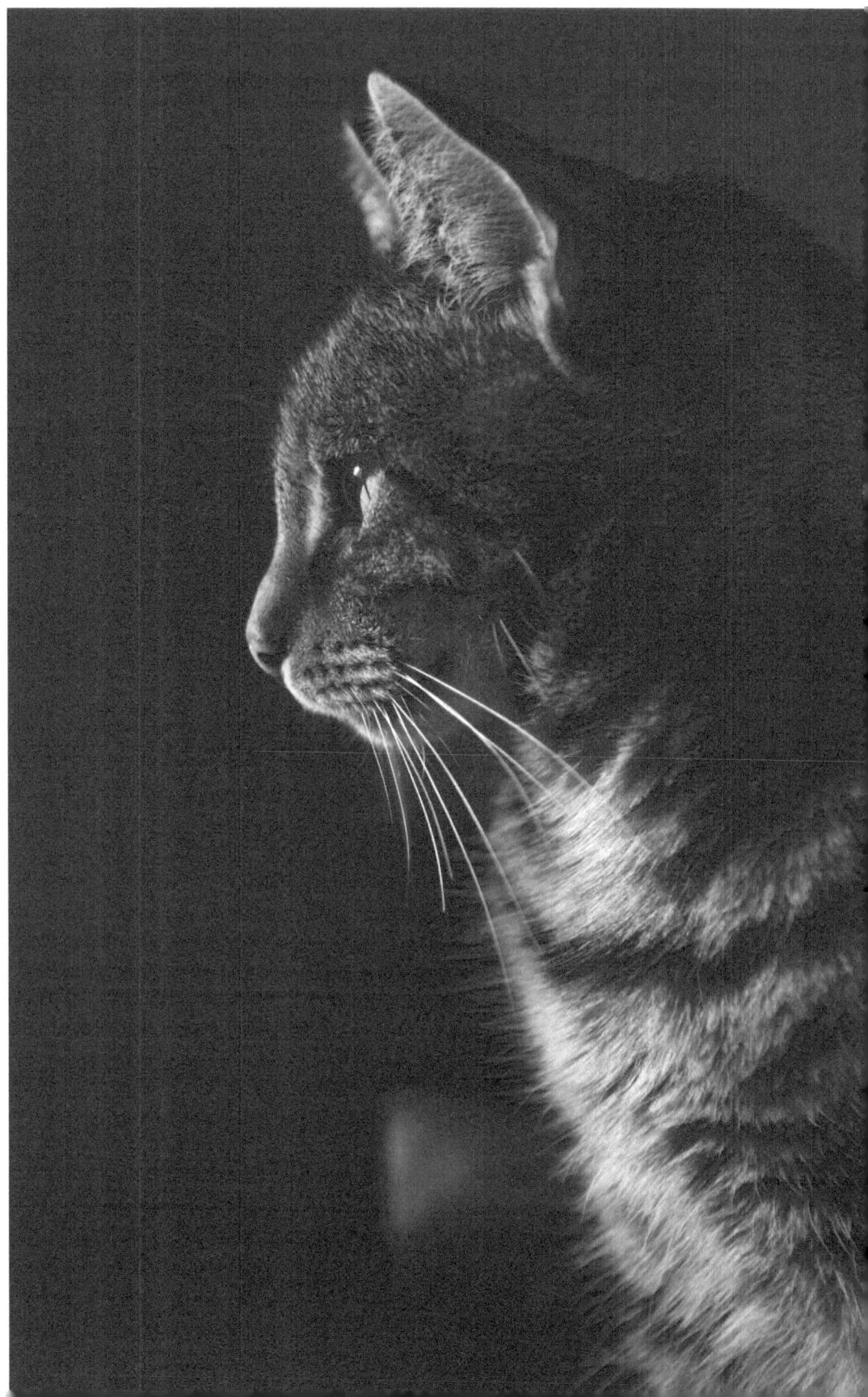

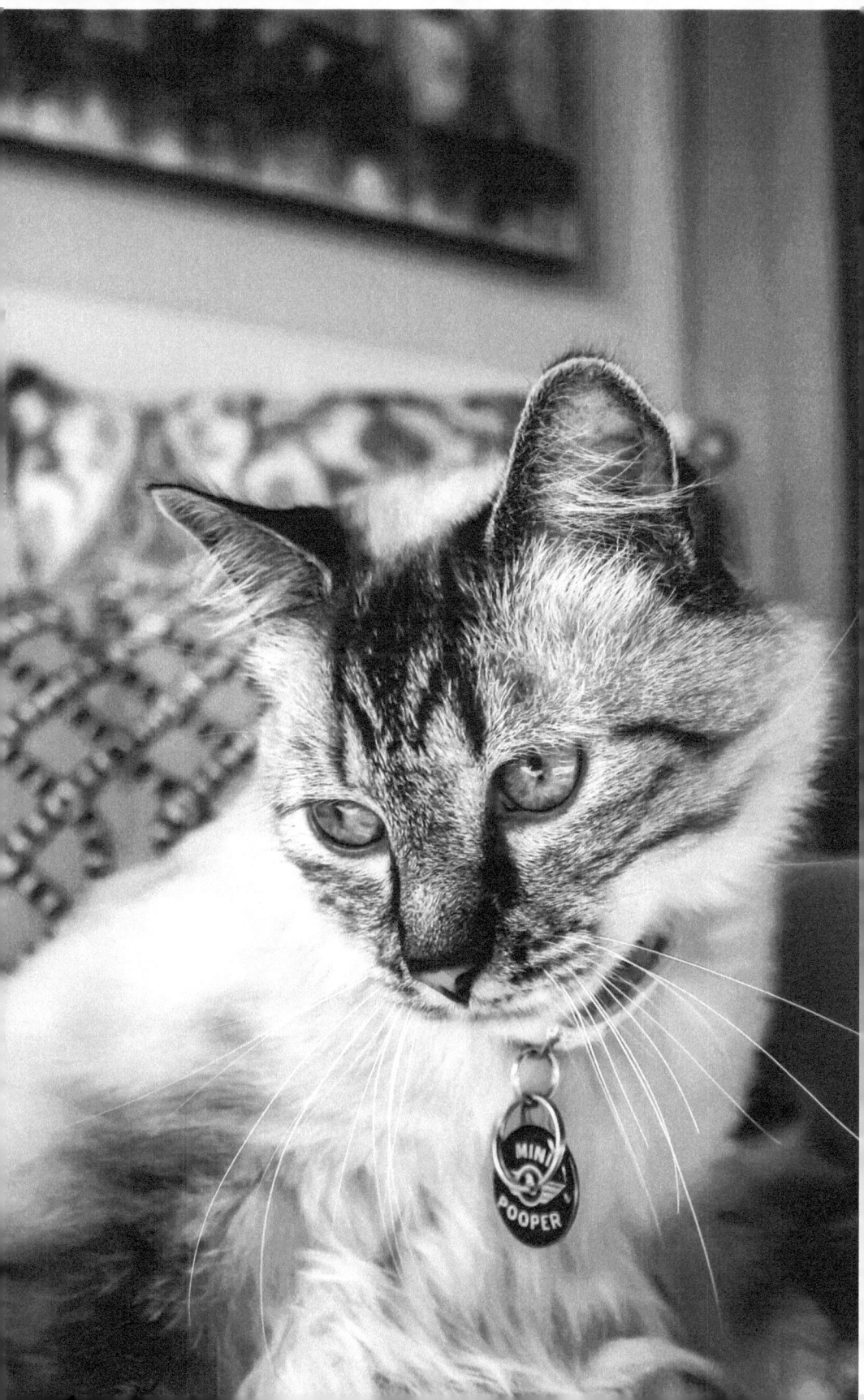

WHAT GREATER GIFT THAN THE LOVE OF A CAT.

CHARLES DICKENS

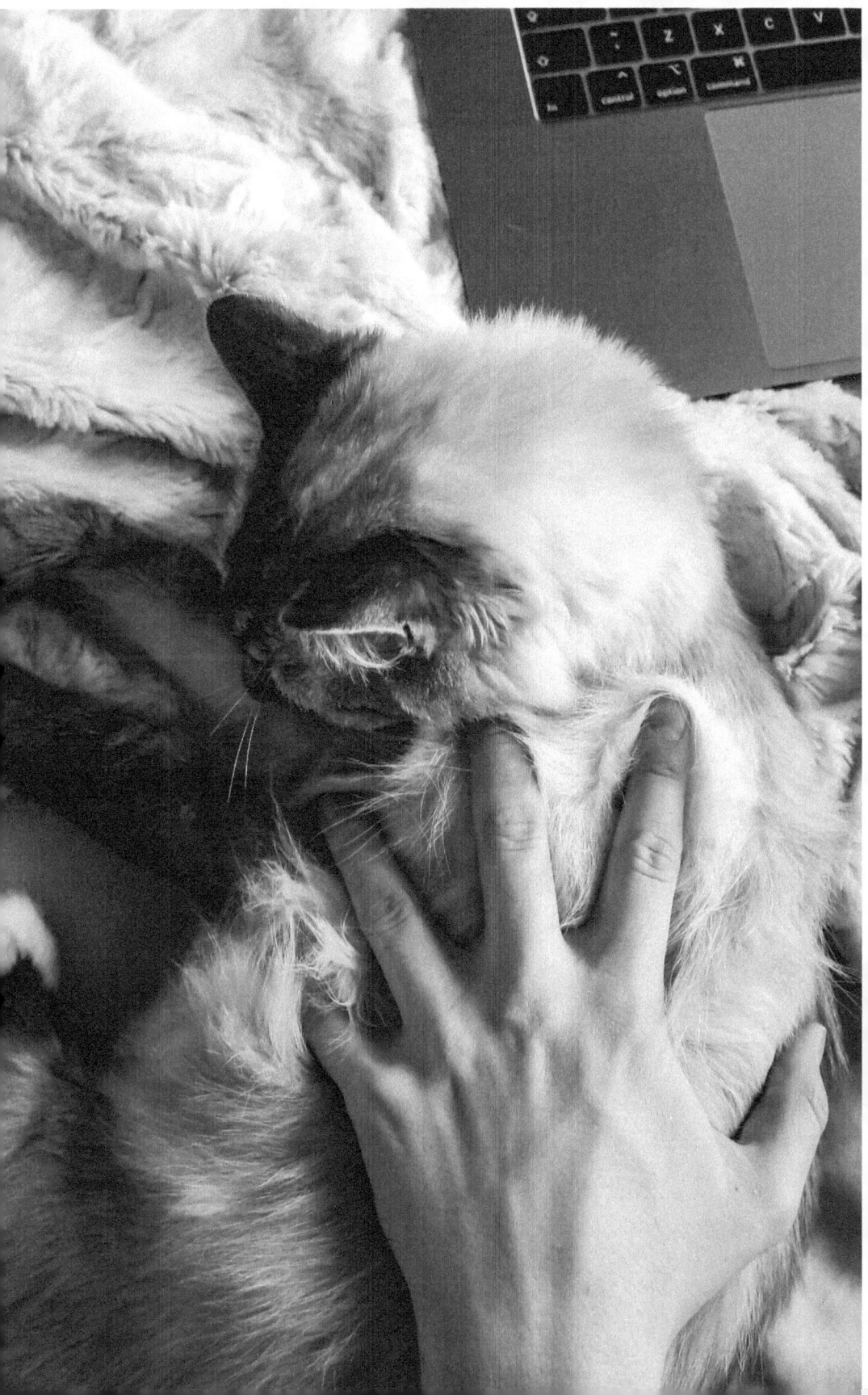

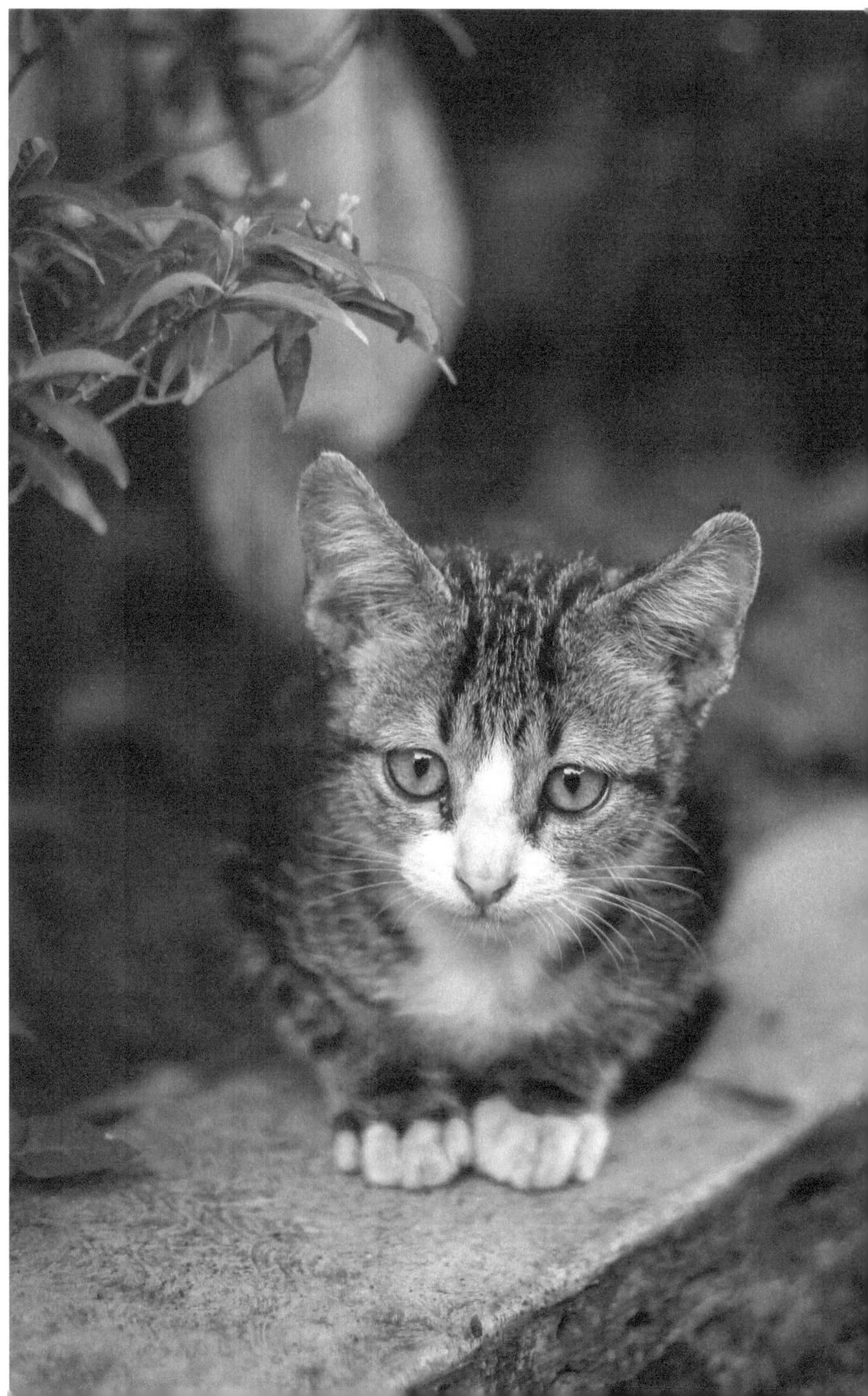

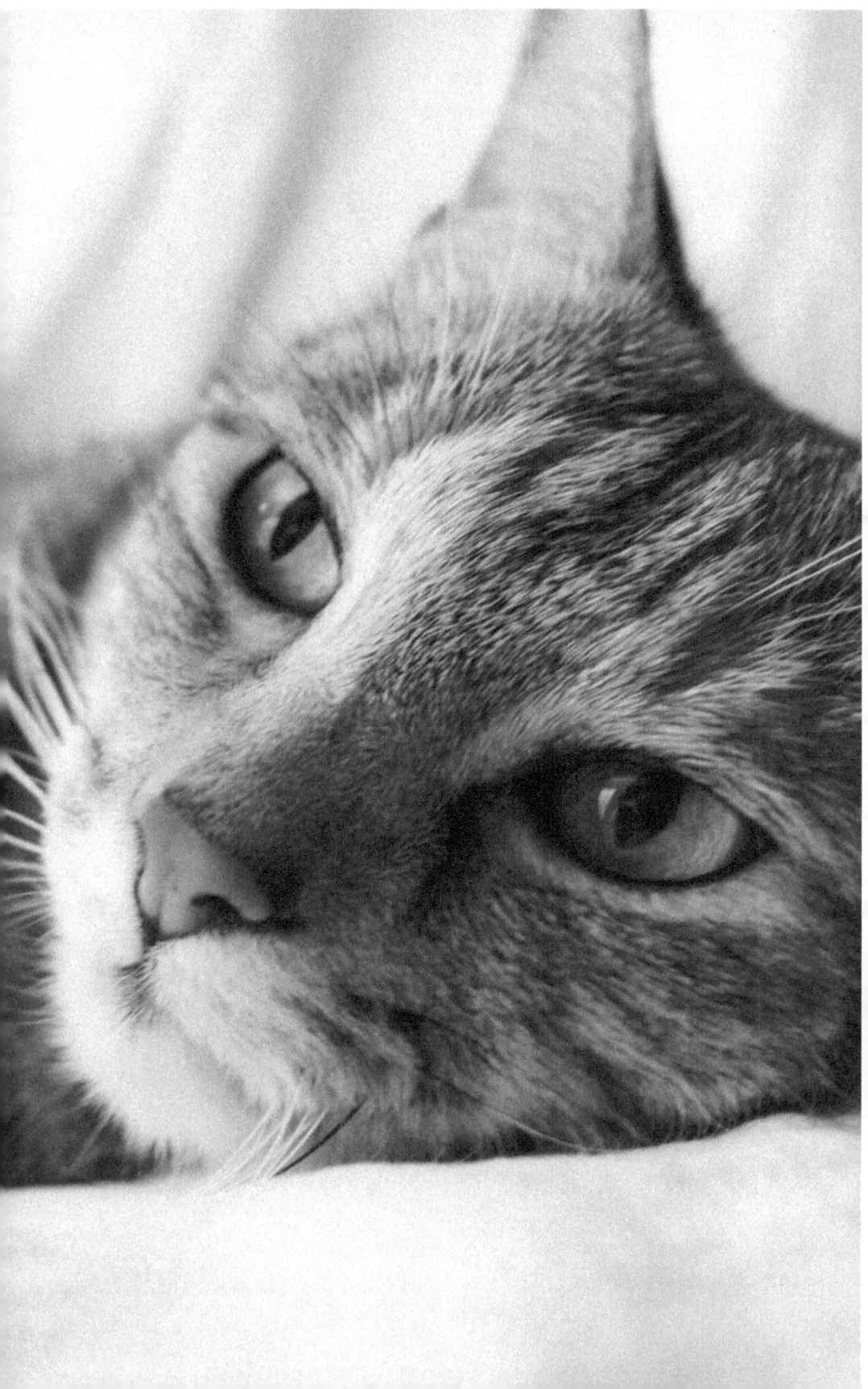

IT IS DIFFICULT TO OBTAIN THE FRIENDSHIP OF A CAT. IT IS A PHILOSOPHICAL ANIMAL... ONE THAT DOES NOT PLACE ITS AFFECTIONS THOUGHTLESSLY.

THEOPHILE GAUTIER

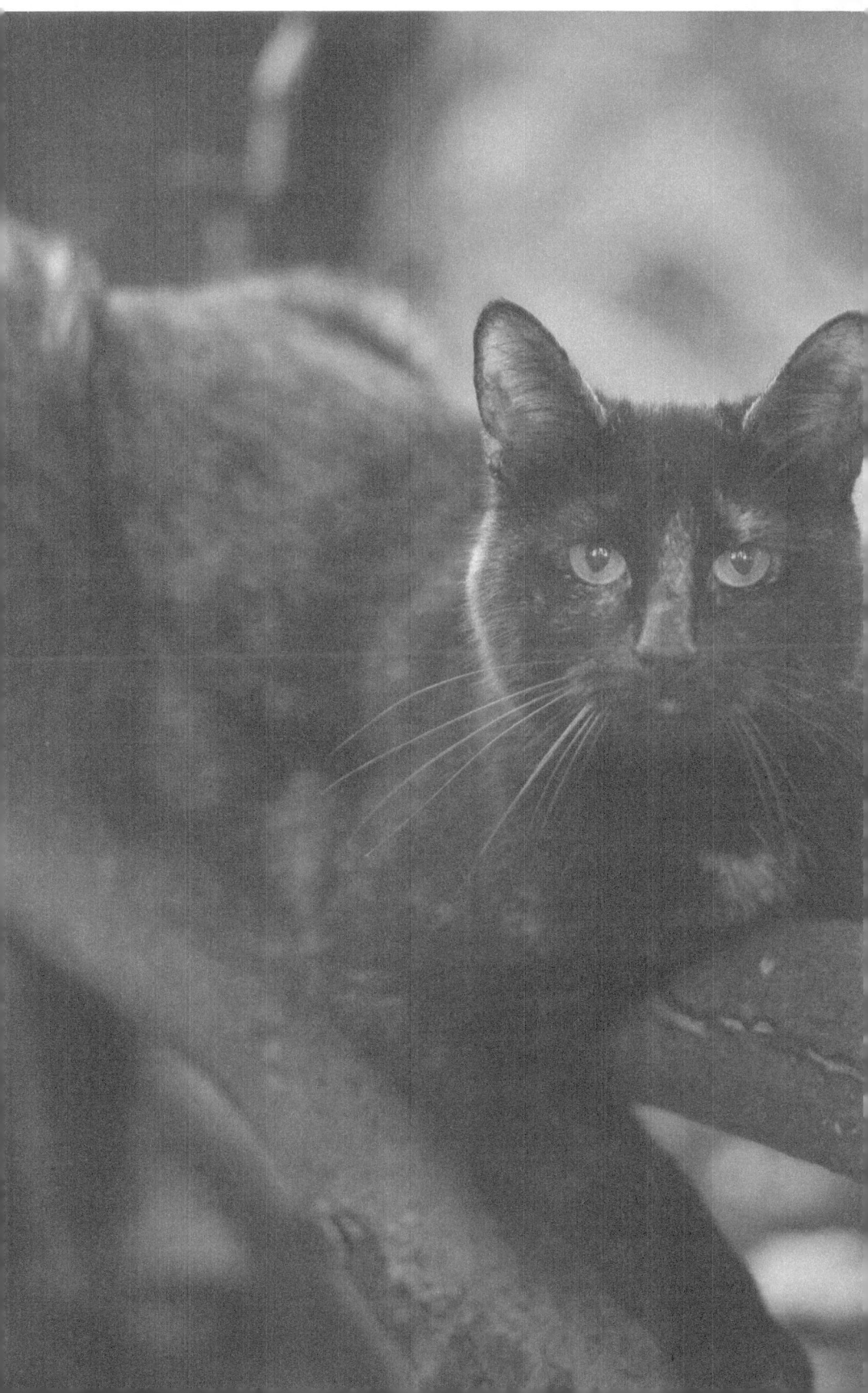

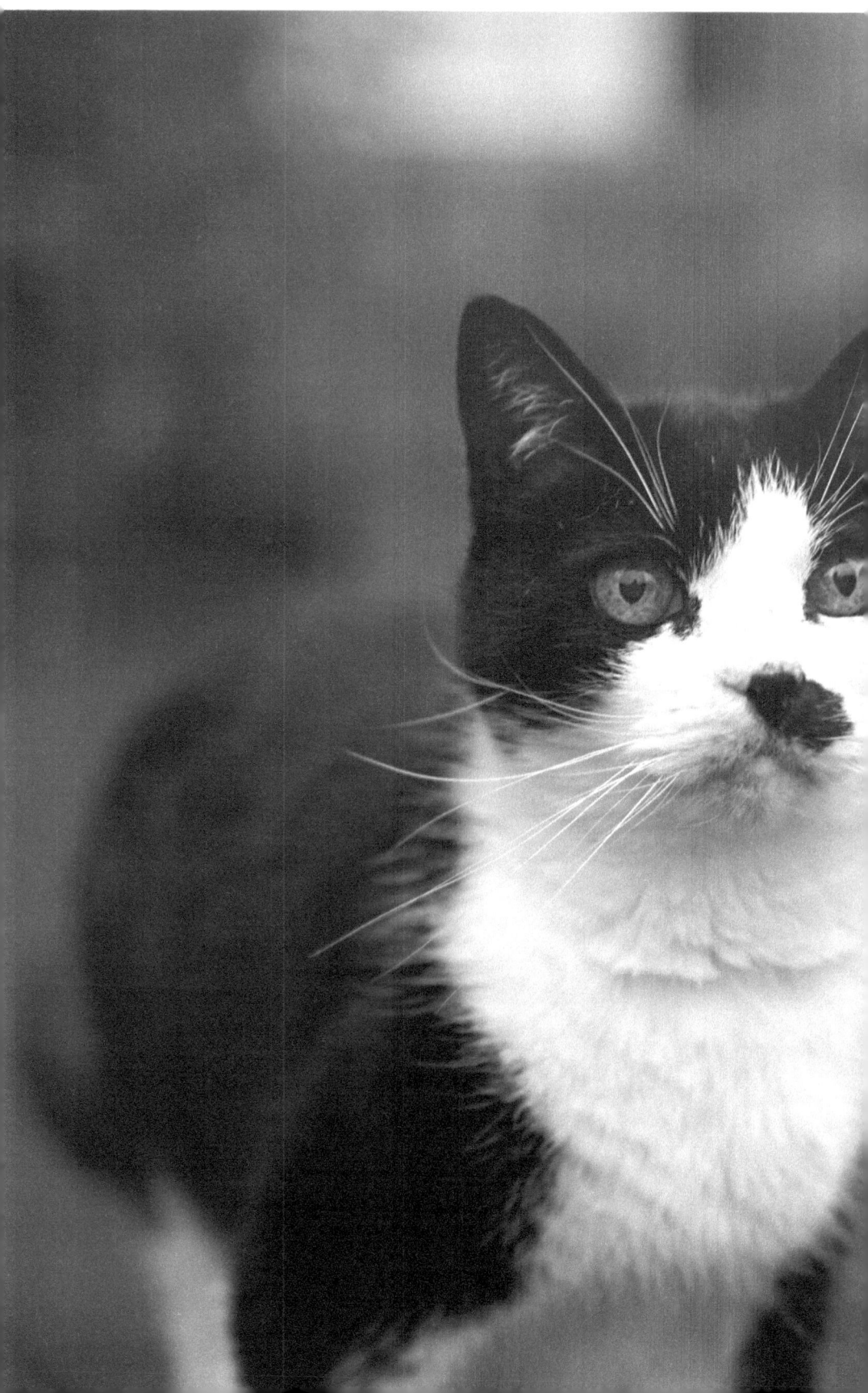

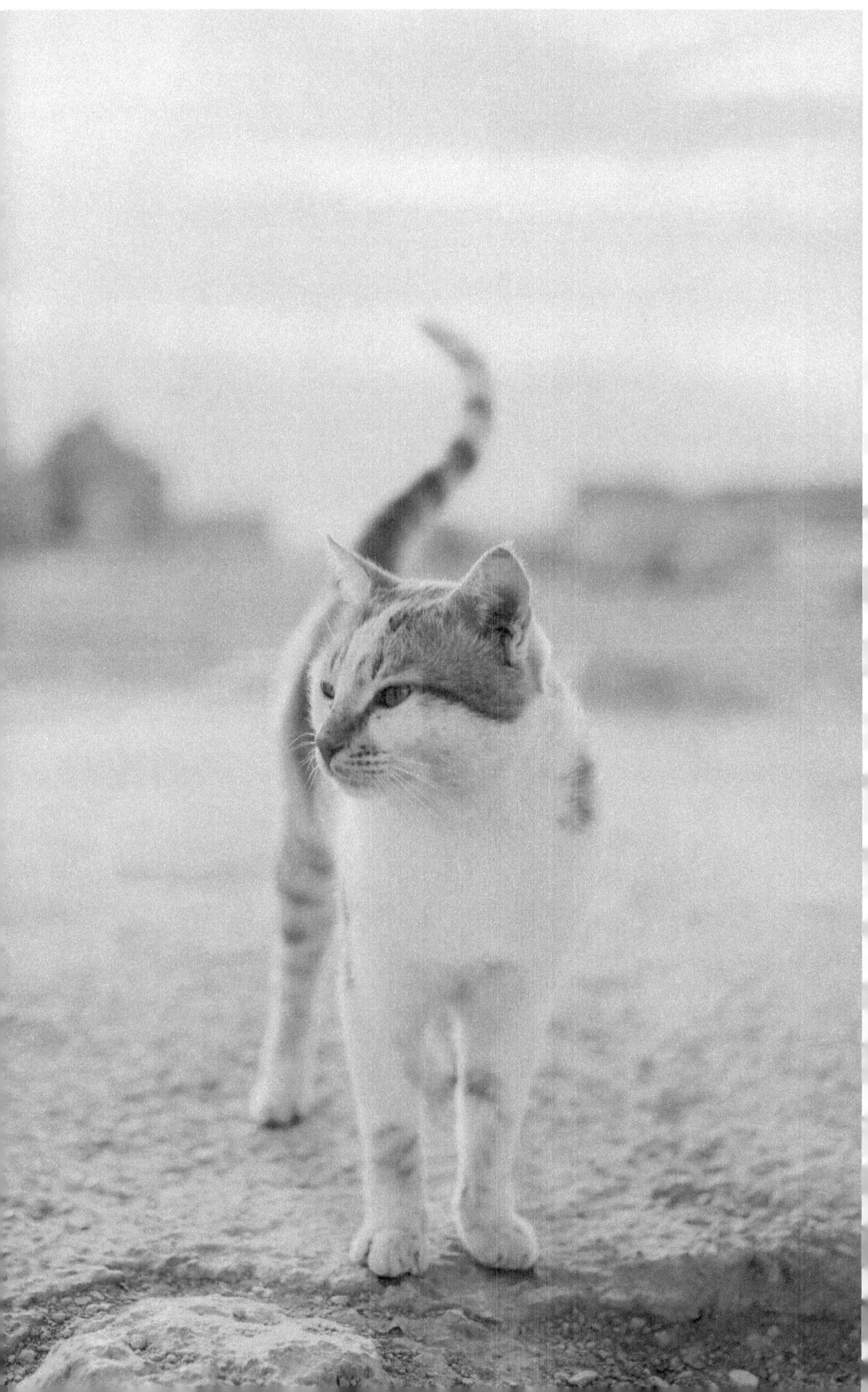

I HAVE LIVED WITH SEVERAL ZEN MASTERS -- ALL OF THEM CATS.

ECKHART TOLLE

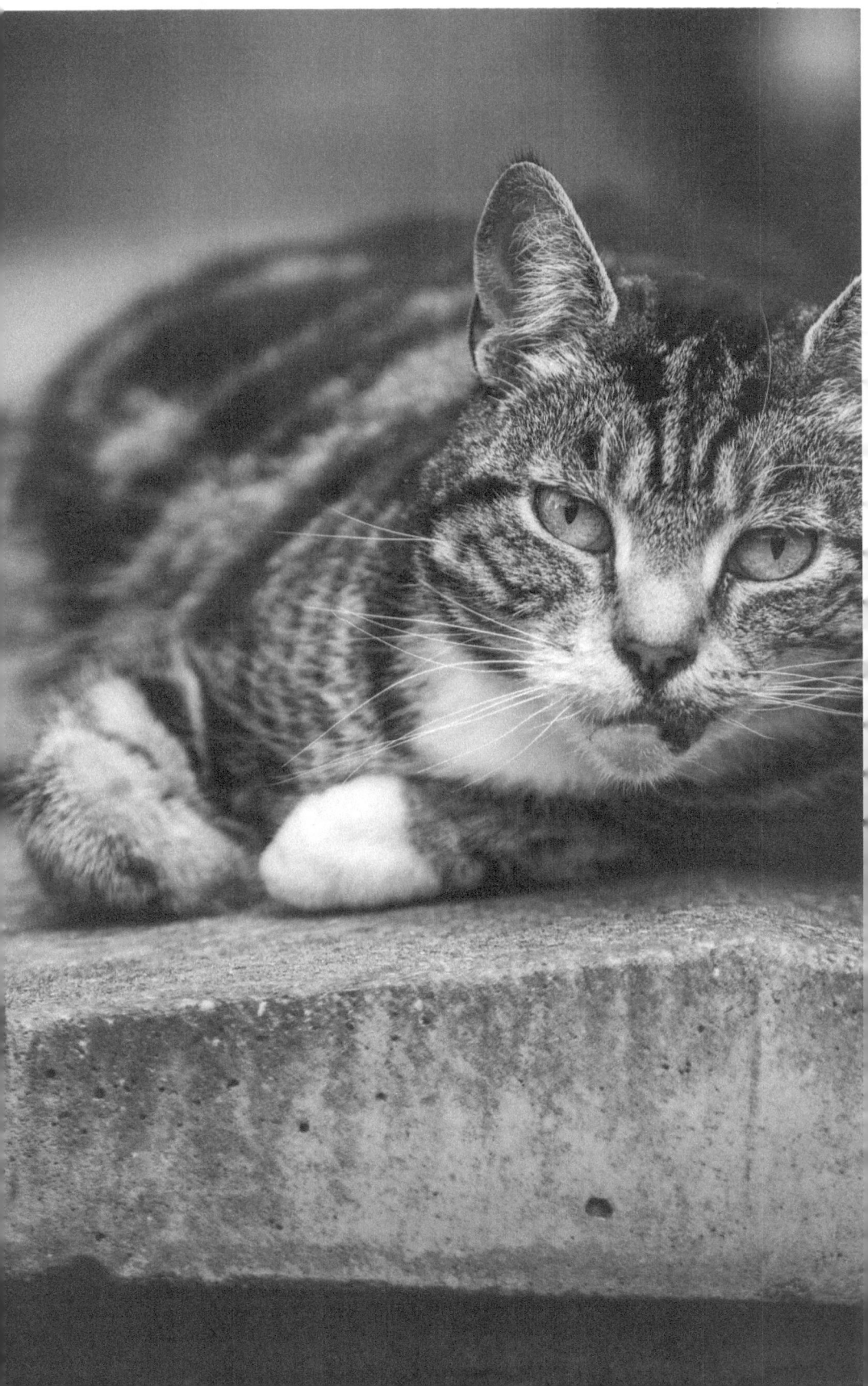

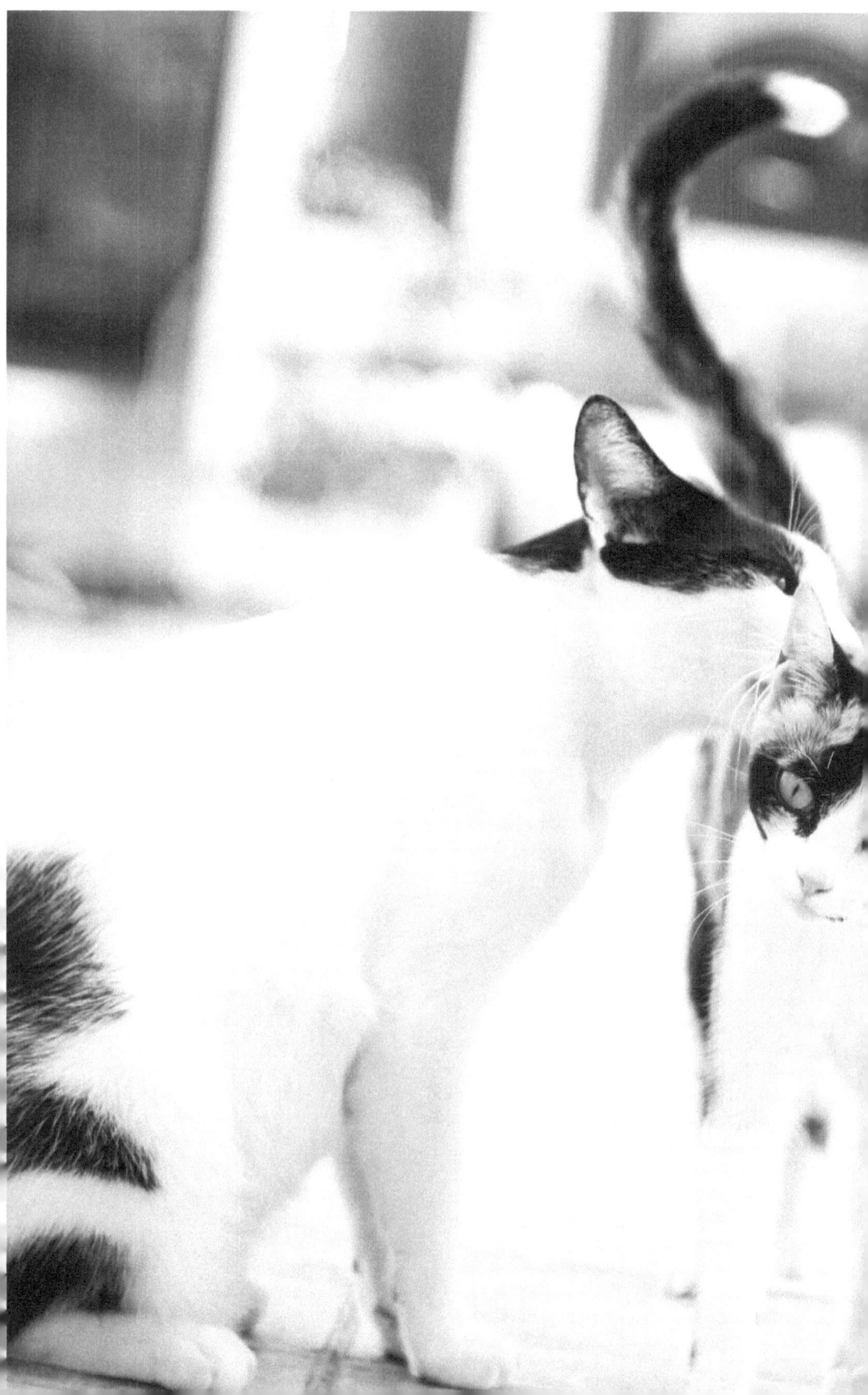

CATS INVENTED SELF-ESTEEM.

ERMA BOMBECK

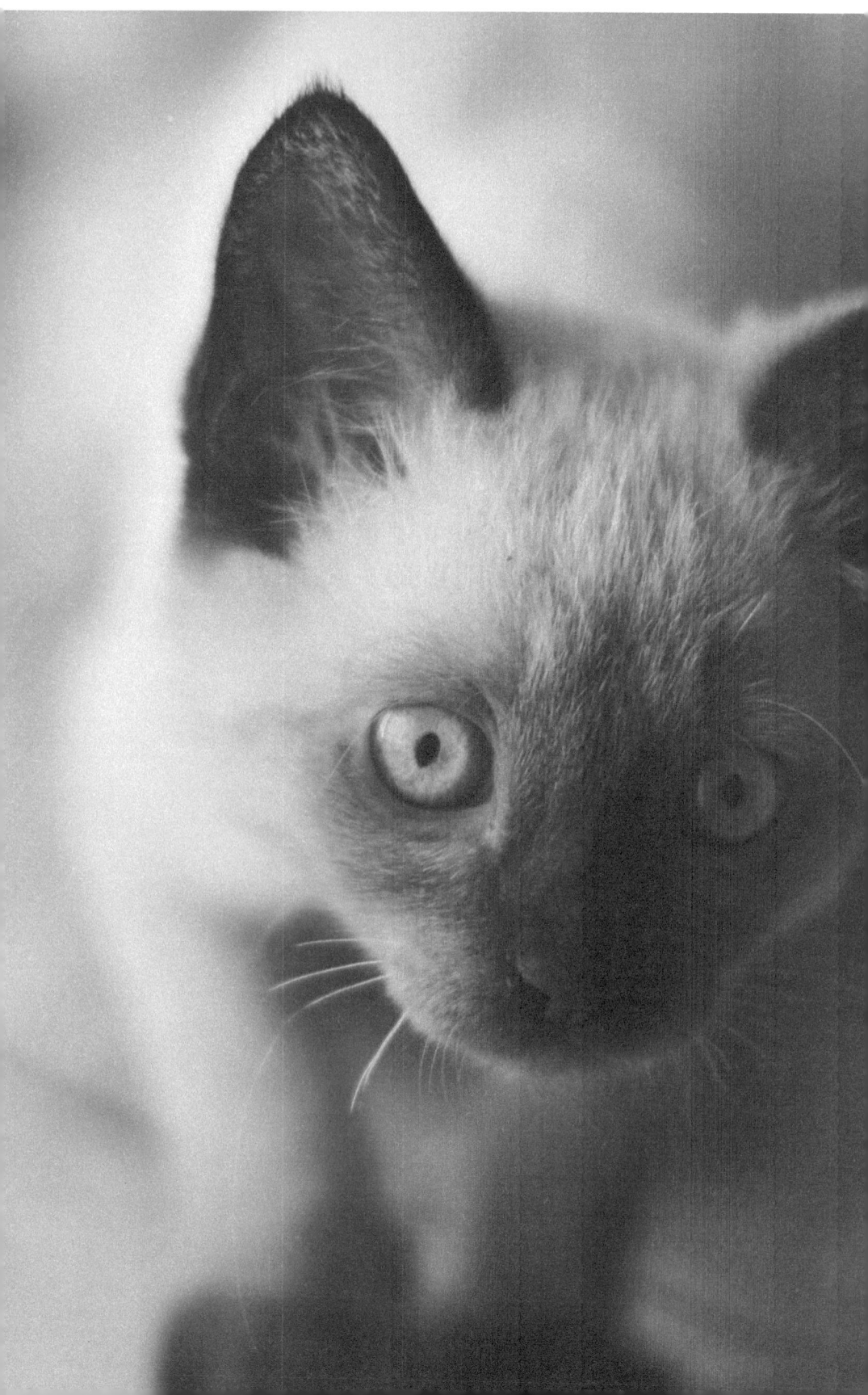

CATS WERE PUT INTO THE WORLD TO DISPROVE THE DOGMA THAT ALL THINGS WERE CREATED TO SERVE MAN.

PAUL GRAY

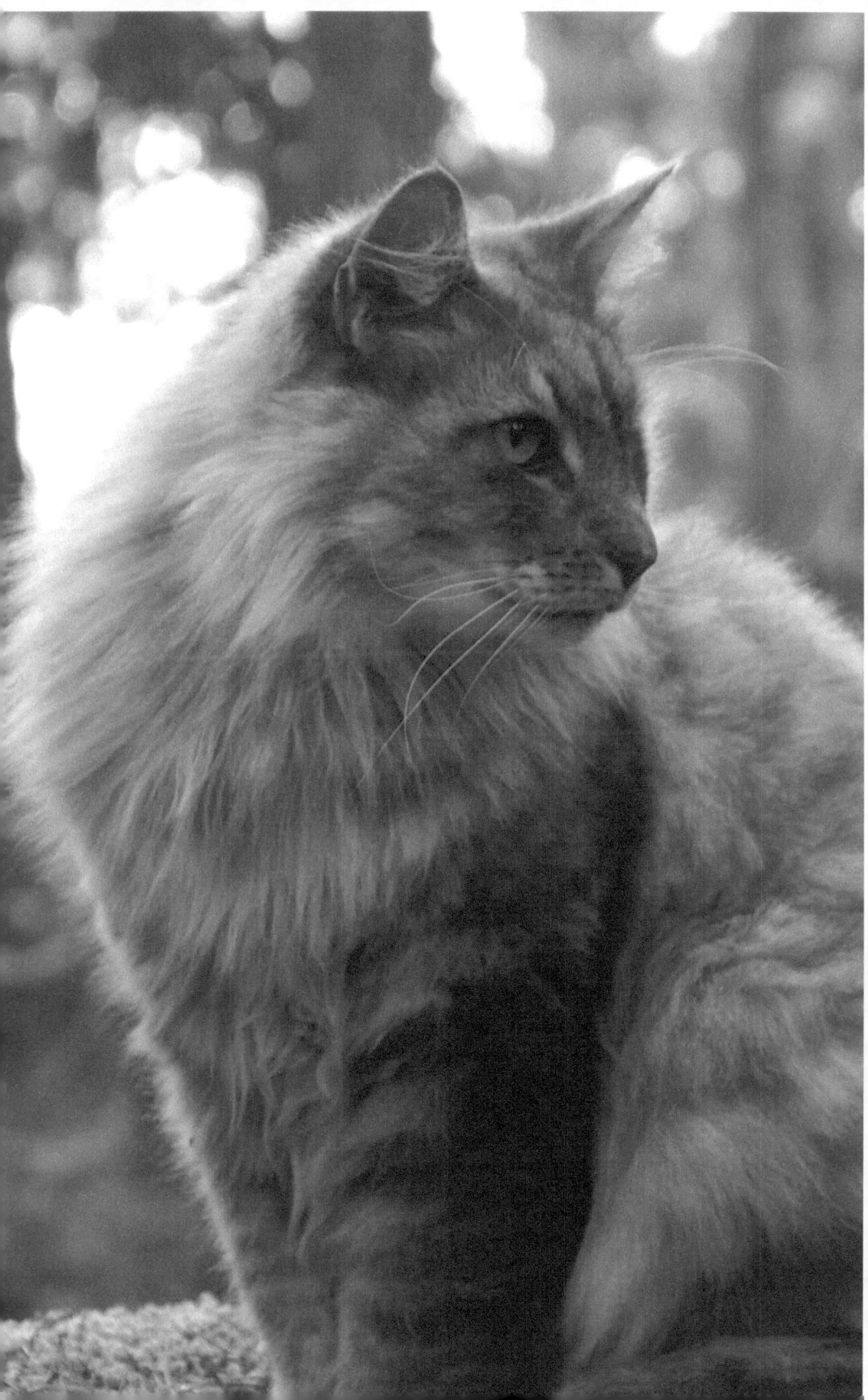

www.ingramcontent.com/pod-product-compliance
Lightning Source LLC
Chambersburg PA
CBHW031502210526
45463CB00003B/1041